CLASSIC NATURAL HISTORY PRINTS

FISH

ACKNOWLEDGMENTS

The authors and publishers would like to thank the following for their help in the compilation of this book:
The National Museums of Scotland: David Heppell of the Department of Natural History; the Head of Library, Manjil V. Mathew and his staff. The National Library of Scotland, Edinburgh: the Superintendent of Reference Services. The Natural History Museum, London: the Head of Library Services, Rex Banks and his staff. The Linnean Society of London: the Council and Librarian, Gina Douglas. Ken Smith Photography (Edinburgh). Cavendish House, Carlisle: Una Dance, Robert Dance.

They would also like to thank the following for their kind permission to photograph the original prints in their possession:
The National Museums of Scotland, Edinburgh, for the plates appearing on pages 13, 23, 25, 27, 41, 43, 45, 57, 61, 65, 67, 69, 71, 83, 85, 87, 89, 91, 93, 95, 97, 99, 101, 103, 105, 107, 109, 111, 113, 115, 117, 119, 121, 123, 125, 127; The Natural History Museum, London, for the plates appearing on pages 9, 11, 15, 35, 37, 39, 51, 53, 55, 59, 63, 73, 75, 77, 79, 81; The Linnean Society of London, for the plates appearing on pages 17, 19, 29, 33, 47, 49; The National Library of Scotland, Edinburgh for the plates appearing on pages 21 and 31.

Classic Natural History Prints, *Fish*
First published in Great Britain in 1990
by Collins & Brown Limited
Mercury House
195 Knightsbridge
London SW7 1RE

Created, designed and produced by Studio Editions Ltd.
Princess House, 50 Eastcastle Street
London W1N 7AP, England

ISBN 1 85585 070 2

Printed and Bound in Italy

CLASSIC NATURAL HISTORY PRINTS

FISH

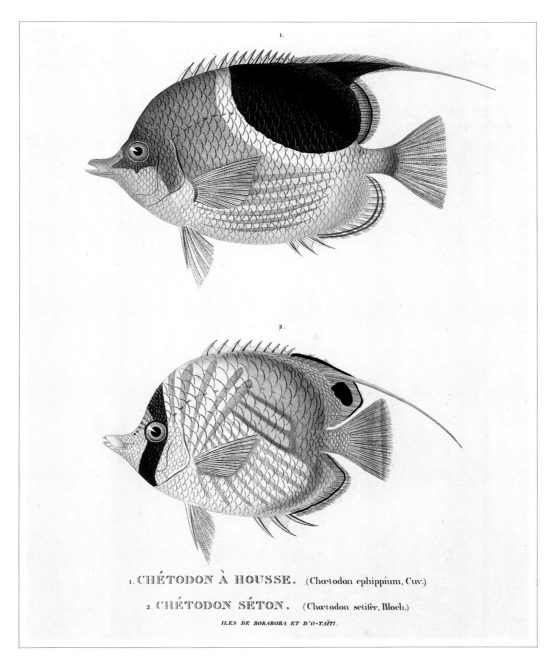

1. CHÉTODON À HOUSSE. (Chœtodon ephippium, Cuv.)

2. CHÉTODON SÉTON. (Chœtodon setifer, Bloch.)

ILES DE BORABORA ET D'O-TAÏTI.

S. PETER DANCE
AND
GEOFFREY N. SWINNEY

COLLINS & BROWN

INTRODUCTION 5

LIST OF PLATES

INTRODUCTION

This book is about art as a by-product of science. Specifically, it is about pictures of fish contained in books published between the early eighteenth and the early twentieth century, a period when artists, engravers and printers pooled their talents to produce illustrations for natural history books. All these books are valuable commodities in the antiquarian book trade, most are still important in the scientific study of fish and few are readily available to the general public. Most of the surviving copies are owned by wealthy book collectors or are preserved in the libraries of learned institutions. They deserve to be better known. This annotated selection of the plates they contain should at least rescue some of the more outstanding of them from partial obscurity and introduce them to a wider audience.

Arranged in chronological order, they show how fish illustration developed before the widespread use of photo-mechanical reproductions. Our selection includes Renard's gaudy phantasms, the sumptuously coloured engravings of fish published by Bloch, the meticulously accurate chromolithographs of Indonesian fish by Bleeker and the silvered images of eerie deep-sea fish by Emma Kissling. These and many more provide a kaleidoscopic view of a specialised, difficult and fascinating art.

Although fish are familiar to us all, in many ways we do not really know them. They share our planet but their world is not ours. We air-breathing humans are largely excluded from their world, the surface of which covers three-quarters of the planet. Fish live in nearly every aquatic habitat, from sparkling mountain streams to the deep oceans where the sun never penetrates. They come in a bewildering array of sizes, shapes and colours. There are mighty giants like the whale shark, 60 feet long and weighing 25 tons or more, and midget gobies less than half an inch long. Between these extremes the shapes of fish are many and varied. Most of them have torpedo-shaped bodies: but there are flattened fish, such as the familiar plaice; elongate fish, such as eels; fish resembling boxes with fins stuck on them; globular fish beset with spines; ribbon-like fish; fish with long snouts and fish with parrot-like beaks; fish like little upright horses; fish with huge gaping jaws above which they dangle enticing lures to catch other kinds of fish. Similarly, the variety of colour and pattern is apparently endless and sometimes astonishingly beautiful.

With such a richness of form and colour it is surprising that fish have not featured more prominently in western art. One reason for this is their other-worldliness. Hauled out of the water a fish is transformed almost immediately. It changes from an elegant, graceful, colourful creature into a floppy, drab corpse – there is nothing as dead as a dead fish. For fish artists attempting to depict their subjects accurately it must have been most frustrating to watch them changing colour as they worked. To overcome this problem they had to work rapidly, hold the subtle hues in their minds or have available a succession of freshly caught specimens. Sometimes they failed and, as some of our pictures show, produced pictures of fish which had been dead for some time. But the fish artists who made the images reproduced in this book were less interested in imbuing their subjects with life than in providing technically detailed likenesses of fish. Their pictures show us fish laid out as though on a mortuary slab, fins and spines erect, the colours of life preserved in death for our inspection. At the same time those pictures reveal the beauty and sometimes the mystery of creatures whose lives we may only dimly perceive.

The problem of recording the correct colours of fish is compounded by the very nature of those colours. Apart from the difficulties of representing subtle tints it is almost impossible to capture, using pigments alone, the iridescence characteristic of many fish. John Gould had a similar problem when producing the illustrations for his great book on the humming-birds in the middle of the nineteenth century. He attempted to produce an iridescent sheen by applying watercolour washes over gold leaf. In the plumage of humming-birds, the iridescence is caused not by pigments but by light reflected from crystals. In fish the crystals are in the skin, each crystal acting like a minute mirror. Some of our artists were remarkably successful at reproducing the subtle hues of fish using pigments alone but others employed a mixture of pigments and metallic paints to achieve stunning effects. With few exceptions, such as *The Game Fishes of North America*, which was conspicuously aimed at the angling fraternity, this obsession with accuracy and realism had one main objective: to illustrate scientific works. Most of the publications from which we have made our selection were scientific in intent.

Ichthyology, the scientific study of fish, began with the Greek philosopher and scientist Aristotle. In the fourth century BC he set about cataloguing the natural world, a process which continues to this day. Aristotle's catalogue included 118 kinds of fish, all that were known then, and not until the Renaissance were significant additions made to it. By then technological innovations had made it possible to obtain multiple copies of both texts and illustrations. By the mid-sixteenth century the first illustrated books about fish had been published, the illustrations being uncoloured woodcuts. Up to that time virtually all fish known were from the Mediterranean and the eastern Atlantic. With the expansion of trade into distant regions, however, seamen, merchants and travellers began to encounter unfamiliar fish. The first fish book to be issued with coloured illustrations portrayed some of them.

Published at Amsterdam in 1719 by Louis Renard, it featured 415 engravings of fish and 45 of other creatures. The engravings were based upon original paintings made at Ambon in the Molucca Islands by Samuel Fallours, an artist employed by the Dutch East India Company. The fantastic shapes and colours of the fish – and even more the inclusion of a mermaid – belie the claim that the paintings were all taken from nature. The first edition, comprising only a hundred copies, is now one of the great rarities of ichthyological literature, a mere thirteen copies having survived. Two virtually identical and now equally rare editions were issued subsequently. We have selected illustrations from the first and second editions.

At about this time a wealthy Amsterdam apothecary, Albert Seba, acquired some exotic fish and incorporated them into his private museum. A young Swedish biologist, Peter Artedi, travelled to Amsterdam to make notes on these and other fish in Seba's collection. This was to be one of the last acts of the man now often referred to as the Father of Ichthyology for while in

Amsterdam he fell into a canal and was drowned. Fortunately his notes survived and were edited to form the basis of the fish section of the massive book known as Seba's *Thesaurus*, which described and illustrated the collection.

Meanwhile, on the eastern shores of the New World an Englishman, Mark Catesby, had been studying wildlife. The book he published, illustrated entirely by himself, includes several studies of fish and he makes a particular point of stressing the difficulty of capturing their elusive colours.

The *Ichtyologie* of Marcus Elieser Bloch now commands our attention. Originating as a work on the fish of Germany, its scope was soon extended to incorporate all species of fish and it became the most lavishly illustrated fish book ever. David Starr Jordan, the eminent authority on North American fish, wrote of Bloch's book, 'In his great work is contained every species which he had himself seen, every one which he could purchase from collections, and every one of which he could find drawings made by others. That part which relates to the fishes of Germany is admirably done. In the treatment of East Indian and American fishes there is much guesswork and many errors of description and of fact, for which the author was not directly responsible.' But it is the stunning beauty of the hundreds of hand coloured plates which now makes this multi-volume work so attractive to book collectors.

The scene shifts to France and the work of Georges Cuvier and his pupil Achille Valenciennes. In their monumental *Histoire Naturelle des Poissons*, published in 22 volumes from 1828 to 1849, they attempted to summarise all that was known about fish. Helped by a team of artists, engravers and colourists, they laboured to describe and illustrate more than 4,500 species; but the work was never completed, for already ichthyology had become too large a subject to be dealt with in a single comprehensive work. Henceforth major illustrated works were to deal with fish of certain geographical regions or with fish collected during particular expeditions.

Among the more lavishly illustrated reports of expeditions conducted during the first half of the nineteenth century were those describing the scientific results of global circumnavigations by the French. These included the voyages of the *Coquille* and the *Astrolabe* (which was actually the *Coquille*, renamed) during which many specimens were collected, especially from the tropical waters of Polynesia. These specimens, together with the notes and sketches made by the naturalist-artists who accompanied the voyages were returned to Paris and there became the basis of the published expedition reports. These contained many beautiful illustrations. For the French, unlike the British and the Germans, were as enthusiastic about art as they were about science – and it shows. The coloured illustrations of fish published in the French expedition reports, particularly those based on original paintings and sketches by Jean René Constant Quoy, one of the naturalist-artists who sailed with the *Astrolabe*, have never been surpassed for beauty, delicacy and accuracy.

The delicate, precise lines of these French engravings contrast strikingly with the thick, broken lines and shadings in the lithographed prints favoured increasingly by British, German, Italian and other European publishers of natural history books in the nineteenth century. The lithographic process, developed in Germany early in the nineteenth century, differs fundamentally from the line engraving process. Briefly, an engraving may be described as a print obtained from a metal plate upon which a design has been scored by a sharp instrument and inked. The ink settles into the lines, the plate is covered by a sheet of paper and

an impression is transferred to the paper. A lithograph is a print obtained from a smooth, flat slab of limestone upon which a design has been drawn with a greasy crayon, the smooth surface having been first dampened with water and inked subsequently. The ink adheres only to the design. The stone is then covered by a sheet of paper which receives an impression of the design. Apart from being simpler and much cheaper than line engraving, the lithographic process allows the artist to draw on the stone himself (engraving in metal requires a higher order of skill and is usually left to an expert).

Compare the lithograph of a batfish from Philipp Franz von Siebold's *Fauna Japonica*, published in the 1840s, with the line engraving of four seabass from the *Atlas* accompanying the scientific report of the voyage of the *Astrolabe*, published in the previous decade. Each illustration successfully served a similar scientific purpose, but the French engraving did more: with supreme confidence it continued an artistic tradition which had begun many years earlier in France, a tradition which had employed the talents of an unbroken succession of brilliant artists to make pictorial records of animals and plants. The artists and engravers responsible for this illustration and many others, including those which embellish the *Histoire Naturelle des Poissons* of Cuvier and Valenciennes, were all nourished by that tradition. Like many French traditions, it was largely motivated by a love of beauty, elegance and truth. Like many French traditions, too, it was expensive to uphold. Eventually, even in France, the economics of book production neccessitated a switch away from expensive engravings to the cheaper lithographic process. All the illustrations we have selected which were published before the second quarter of the nineteenth century are line engravings; most of those published subsequently are lithographs.

Exploratory journeys during the nineteenth century were not confined to epic sea voyages. This was a period of colonial expansion with daring adventurers exploring and opening up for settlement vast tracts of previously uncharted wilderness. In so doing they encountered many new exotic animals, including fish. The books describing these discoveries contain some delightful illustrations. Our picture of the so-called man-eating piranha is an early lithograph from a regional work, one devoted to the fish of Brazil, while Sir John Richardson's *Fauna Boreali-Americana* provides us with two pictures of fish collected during the second of Sir John Franklin's Arctic expeditions.

It was not only well-equipped, government-sponsored expeditions with naturalists and artists in tow which advanced ichthyology. Occasionally private individuals made valuable contributions to our knowledge of fish by collecting specimens and by making notes and sketches. John Whitchurch Bennett was one of these enthusiastic 'amateurs', his lasting contribution to science being a small publication about the fish he had studied on the coast of Sri Lanka. We have selected one illustration from the first edition of this excellent book, published in London, and another from the second, for it is instructive to compare different editions of a book, if only to see how artistic and printing standards may vary.

The Reverend Richard Thomas Lowe, the English chaplain of the island of Madeira in the middle years of the nineteenth century, was another enthusiastic amateur whose job seems to have left him with plenty of time to study the animals and plants of his sub-tropical parish. He, too, wrote and prepared illustrations for a book about fish. Like Bennett's work Lowe's *History of the Fishes of Madeira* is illustrated with attractive lithographs. Lithography provided a cheap mechanical process for reproduc-

ing illustrations but, like the line engraving process, it delivered an uncoloured image; colouring still had to be done by hand. The colourist's job must have been tedious. Many printing establishments employed several colourists who often worked as a team. One would apply colour to certain parts of a print, hand the print to his or her neighbour who applied another colour and so on until the colouring was complete. Not surprisingly there is often considerable variation among prints illustrating the same subjects. Each hand-coloured illustration is unique, a quality attractive to collectors.

But it was chromolithography, the printing of coloured lithographs by mechanical means, which was used to illustrate one of the great classics of ichthyology, Bleeker's *Atlas Ichthyologique*. Like Bennett and Lowe, Pieter Bleeker began to study fish as a hobby, a diversion from his duties as a surgeon with the Dutch East India Company. His hobby soon became a passion, however, and he ended up as the leading authority on fish of Indonesia. Such was his drive and energy that he also became the most prolific writer in the history of ichthyology, producing an amazing 500 publications. He died in 1878 while working on his *Atlas* having completed nine folio volumes of a projected dozen or so. A treasury of scientific knowledge about the fish of the Indonesian Archipelago, profusely and beautifully illustrated, it is a publication as remarkable in its purpose and almost as aesthetically pleasing in its presentation, as Bloch's *Ichtyologie*. We may be accused of parsimony, perhaps, for including in our book only two of the more than 300 plates Bleeker worked so hard to include in his.

Our selection of plates is not confined to those which have appeared in scientific works, for many fine illustrations of fish have been published to satisfy those who catch fish for sport or for a living. Between 1839 and 1841 Sir William Jardine brought out his *British Salmonidae*, containing a mere handful of excellent engravings, each covering an area the size of a small table top and portraying sporting fish at their natural size, a publication which none but the wealthy could afford to buy or endeavour to shelve. The Reverend William Houghton's *British Freshwater Fishes*, which appeared about forty years later, was more modest in format and more approachable in price. Its delicately coloured wood engravings are now often seen for sale in print shops: this means that copies of the book are regularly being taken apart to satisfy the print trade – to the detriment, ultimately, of the book trade. We have selected no less than four of Houghton's plates, an extravagance we consider justifiable because they are perennially popular and may be appreciated as much for their scenic backgrounds as for the fish they portray.

At the same time as Houghton's book came on to the market a much more flamboyant publication was being published on the other side of the Atlantic. The *Game Fishes of the United States* was written by G. B. Goode, a leading authority on American fish, and illustrated by S. A. Kilbourne. Comparable in page area to Jardine's book it is illustrated with lively portraits of American marine and freshwater fish shown in expansive settings. It is one of the few books published before the twentieth century attempting to show fish in motion, although it should be said that some delightfully graceful images of swimming fish had been captured in Japanese and Chinese prints dating from the eighteenth century or even earlier.

The twentieth century saw new developments in photography allowing both outline and colouring of an illustration to be done as a single automated process. Eventually, under-water breathing apparatus and water-proof housings for both camera and lighting equipment made possible the photography of living fish in colour, in their natural element. Just as in the nineteenth century lithography replaced the more costly line-engraving processes so, in the twentieth, photography has replaced the hand-drawn, hand-coloured illustrations of fish. But the photographs in modern mass-produced fish books and periodicals lack the unique quality hand-colouring gave to the prints of more leisured times. The images we have selected, spanning two centuries, reveal something of the rich artistic legacy stored away in publications which appeared before progress and the profit motive demanded the production of mass-produced images.

Two Exotic Fish

Two Exotic Fish (upper one possibly meant for a Cowfish, family *Ostraciidae*, lower one a flatfish, possibly meant for an Adalah, family *Psettodidae*). Hand coloured engraving after original paintings by Samuel Fallours, pl. 44 from Vol. 2 of Louis Renard's *Poissons, Écrevisses et Crabes*, 1719. Size of plate 11″ × 8″.

The pictures of fish and crustaceans first published in 1719 by Louis Renard have a curious history. Early in the seventeenth century Renard, a self-styled 'Agent of Her Britannic Majesty', acquired two collections of original paintings which had been assembled by successive Governor Generals in the former Dutch East Indies. The subjects of the paintings had supposedly been obtained around Amboyna (now Ambon) and other Indonesian islands. With the promise of some financial help from Hans Sloane, the founder of the British Museum and then a leading figure in the Royal Society of London, Renard managed to have the paintings published in book form at Amsterdam. The first edition, from which this illustration is taken, is now one of the great rarities of natural history literature, only thirteen copies having survived.

The artist used considerable imagination when producing these pictures. The text accompanying the upper one says that it represents a fish about three feet long obtained in 1709 near Amboyna, then an island of considerable importance to the Dutch. The other figure is a flatfish of some sort but we may only guess at a more precise identification. It is said to have been about a foot long and to have come from the Molucca Islands. These are not accurate figures of fish but they have an undeniable charm.

185. Monstre qui fut péché au passage de Baguewal près d'Amboine en 1709. Il etoit long de trois pieds et demi.

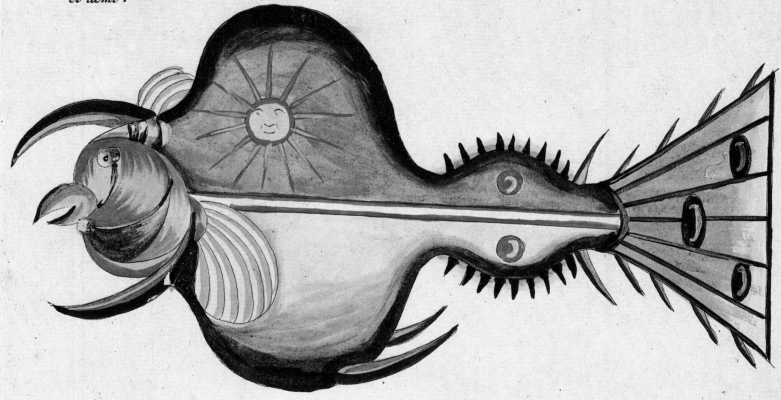

186. Bot ou Plie de la Côte Alforeese très-bonne à toutes Sauces très-belle et diversifiée dans ses couleurs. On en trouve d'un pied de long. il n'y a qu'environ 20. ans que ce poisson a commence d'être connu aux Moluques.

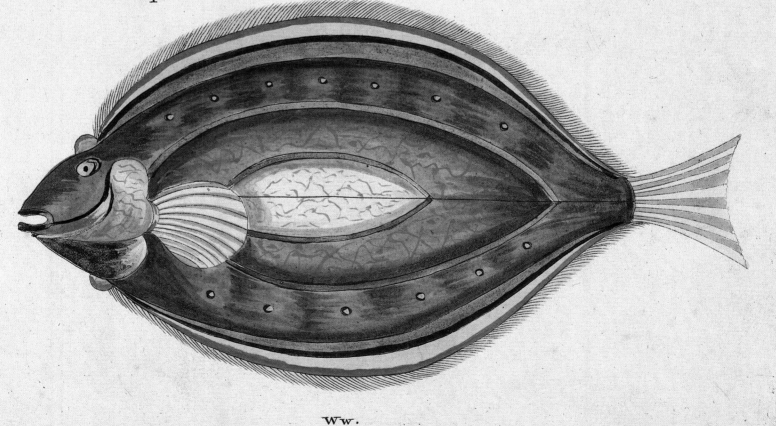

Six Exotic Fish

SIX EXOTIC FISH, (including surgeonfish, angelfish and triggerfish). Hand coloured engraving after original paintings by Samuel Fallours, pl. 4 from Vol. 2 of Louis Renard's *Poissons, Écrevisses et Crabes*, second edition, 1754. Size of plate 11″ × 8″.

The first edition of Louis Renard's fantastic book on tropical fishes appeared in 1719. A second edition was published 35 years later. This edition was seen through the press by Arnout Vosmaer, who later became a prominent figure in scientific circles in the Netherlands, but the illustrations and accompanying text remained virtually identical. This suggests that the book had only curiosity value and that a second edition had been produced to satisfy wealthy collectors of unusual books. This edition, like the first, has now become almost unobtainable.

That the figures are meant to represent mostly generic types of fish is evident from some of the captions engraved next to them. For instance there are said to be various species similar to the 'Long-nose' (second from top). The caption above the triggerfish (fourth from top) states that the curious in the Netherlands have many similar fishes in their collections but that the colours look lifeless and faded. This suggests that the figures were based on paintings done from freshly caught specimens. It may be a loss to science that the man whose work has been immortalised here was not a skilful artist, but lovers of the odd and the fantastic will applaud his naiveté!

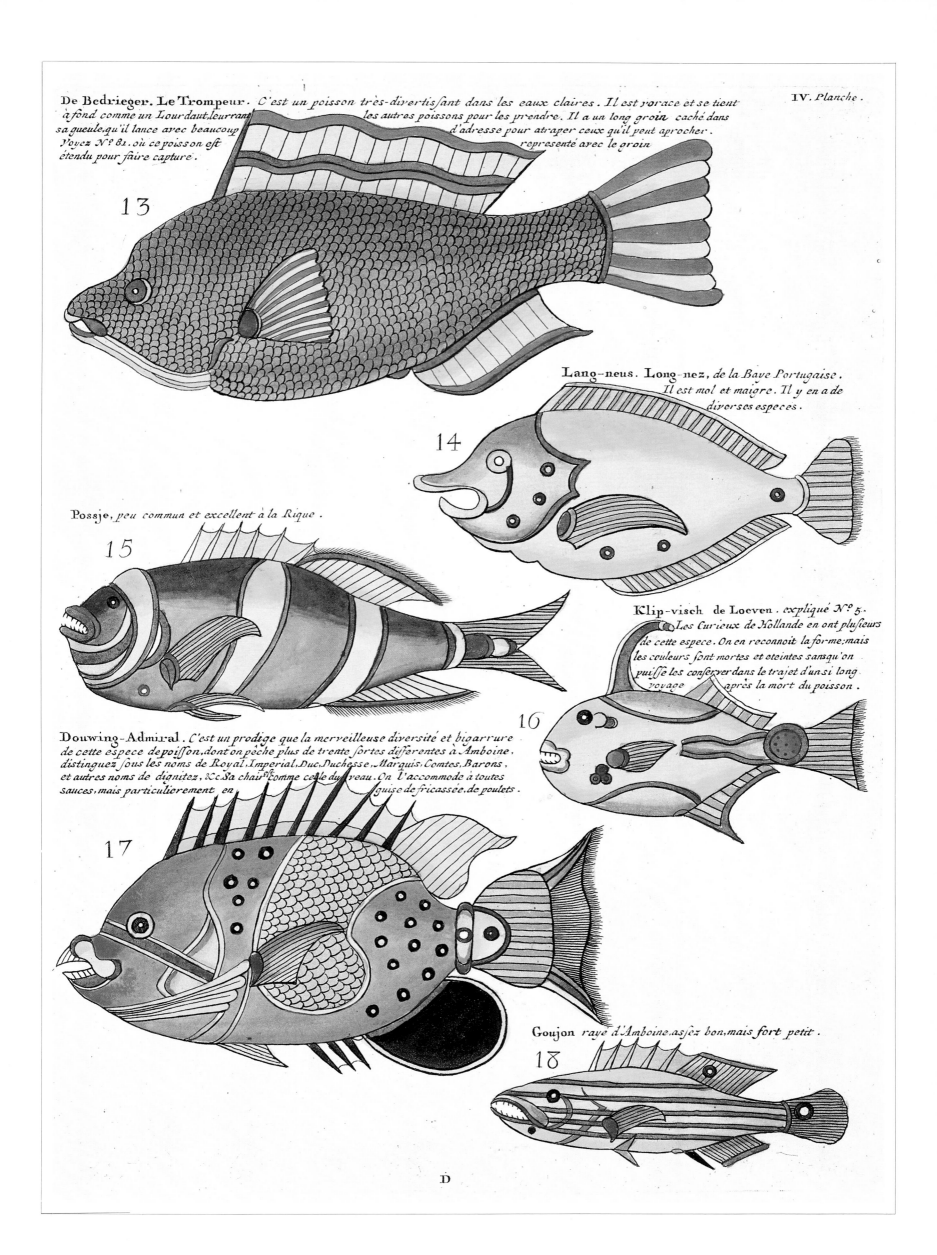

De Bedrieger. Le Trompeur. *C'est un poisson très-divertissant dans les eaux claires. Il est vorace et se tient à fond comme un Lourdaut, leurrant les autres poissons pour les prendre. Il a un long groin caché dans sa gueule, qu'il lance avec beaucoup d'adresse pour atraper ceux qu'il peut aprocher. Voyez N.º 81. où ce poisson est représenté avec le groin étendu pour faire capture.*

13

Lang-neus. Long-nez, *de la Baye Portugaise. Il est mol et maigre. Il y en a de diverses especes.*

14

Possje, *peu commun et excellent à la Rique.*

15

Klip-visch *de Loeven. expliqué N.º 5. Les Curieux de Hollande en ont plusieurs de cette espece. On en reconnoit la forme; mais les couleurs sont mortes et eteintes sans qu'on puisse les conserver dans le trajet d'un si long voyage après la mort du poisson.*

16

Douwing-Admiral. *C'est un prodige que la merveilleuse diversité et bigarrure de cette espece de poisson, dont on pêche plus de trente sortes diferentes à Amboine, distinguez sous les noms de Royal, Imperial, Duc, Duchesse, Marquis, Comtes, Barons, et autres noms de dignitez, &c. Sa chair est comme celle du veau. On l'accommode à toutes sauces, mais particulierement en guise de fricassée de poulets.*

17

Goujon *raye d'Amboine, assez bon, mais fort petit.*

18

D

Spotlight Parrotfish

PARROTFISH (Spotlight Parrotfish, *Sparisoma viride*). Hand coloured engraving by Mark Catesby, pl. 29 from Vol. 2 of his *The Natural History of Carolina, Florida and the Bahama Islands*, 1731–43. Size of plate 13¾″ × 10″.

Mark Catesby's knowledge of the natural history of south-eastern North America and the Bahamas resulted from several years spent in those parts during the first quarter of the eighteenth century. On his return to England in 1726 he set about writing a remarkable book based on that knowledge. Never wealthy, he could not afford to employ a professional engraver to produce the illustrations so essential to the success of a natural history book, so he taught himself to engrave his own plates and then coloured all the prints. He claimed proudly that, with few exceptions, he always painted the animals while they were alive. 'Fish, which do not retain their Colours when out of their Element,' he said, 'I painted at different times, having a succession of them procur'd while the former lost their colours.' As this illustration seems to portray a fish which had been dead for some time – a freshly collected one would have been more brightly coloured – we may assume that his supply of specimens had been inadequate for his artistic purpose. Catesby had unusual ideas about the composition and design of many of the plates in his book. With sublime nonchalance he placed corals on land, juxtaposed snakes with any plants which took his artistic fancy and, most incongruous of all, suspended a fish in a tree! The effect of these arrangements is at once amusing and decorative.

The species illustrated attains a length of 20 inches and its range encompasses Bermuda, the Bahamas, Florida, and the eastern Gulf of Mexico to Brazil.

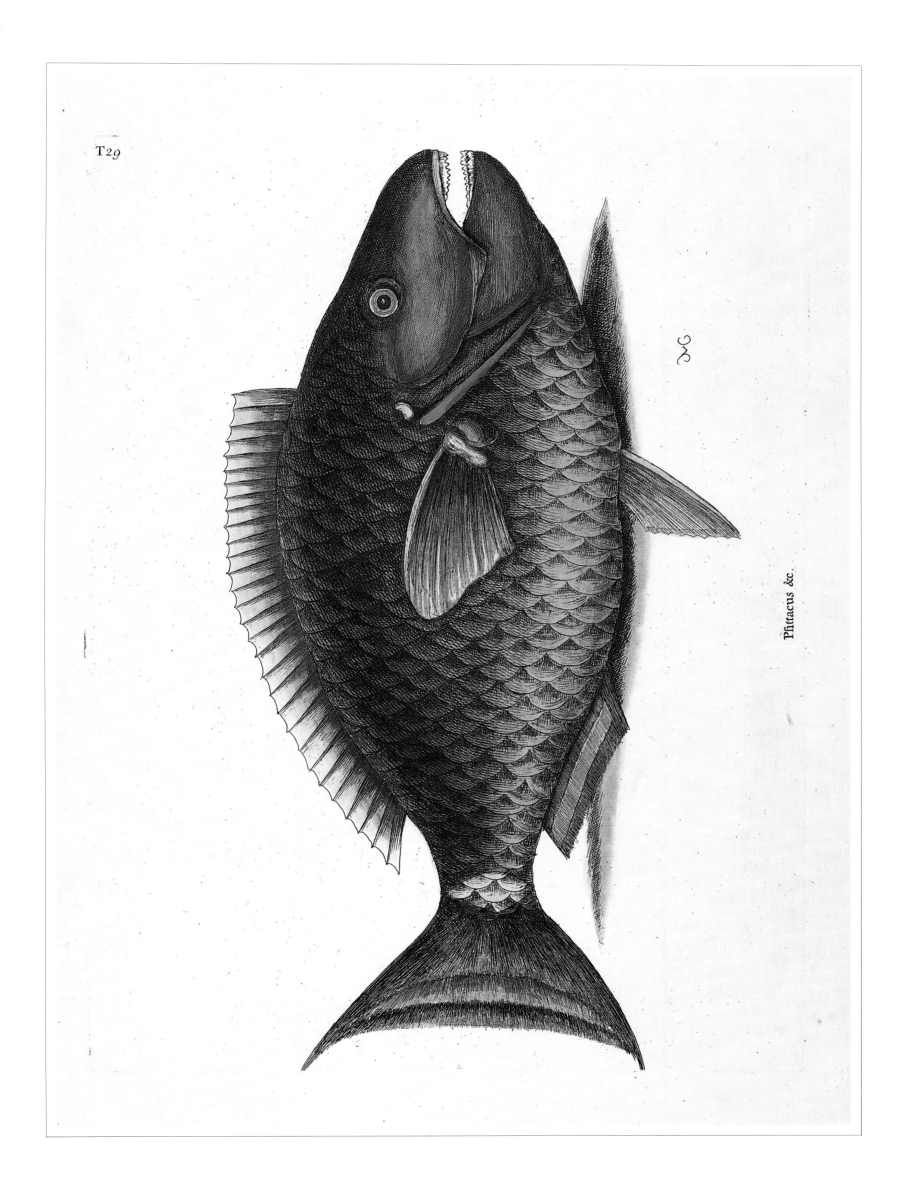

Pfittacus &c.

Flying Gurnard and other Fish

FLYING GURNARD (*Dactylopterus volitans*) (bottom) and various other fish. Hand coloured engraving by P. Tanjé, pl. 28 from Vol. 3 of A. Seba's *Locupletissimi Rerum Naturalium Thesauri Accurata Descriptio &c*, 1734–65. Size of plate 17¼″ × 11″.

It would be possible to spend many hours trying to identify the species of fish represented on this plate but as there are so many we will just say that the fish shown at the bottom is a species of flying gurnard, which we have mentioned elsewhere, and instead comment upon the man in whose magnificent book this plate appears.

Albert Seba was an Amsterdam apothecary who assembled a large collection of natural curiosities which he sold to Peter the Great of Russia in 1717. As he was wealthy and loved collecting he soon assembled a second and larger collection, replete with shells, corals, stuffed creatures of all kinds and preserved fish. Many of his treasures he obtained from the crews of vessels newly returned from the East and West Indies. He was the kind of collector who not only loved curious and novel things, but was also interested in acquiring the sort of immortality conferred by having his name closely associated with a book. He decided that his collection should be immortalised in a lavishly illustrated, folio-sized book, written and illustrated by others but widely – and aptly – known as Seba's *Thesaurus*. It is an amazing book, full of excellent engravings of natural objects curiously posed and artfully arranged. A few copies of this mammoth four-volume production exist with the plates coloured by hand, expensive luxuries to tickle the fancy of wealthy collectors.

Seba died after the second volume of the great work had been published and he never saw the plate reproduced here, which was published in the third volume in 1758. He represented an age which collected and cherished novel, beautiful and curious things and we are fortunate that his wealth was used to preserve such a splendid pictorial record of some of those things.

TAB. XXVIII.

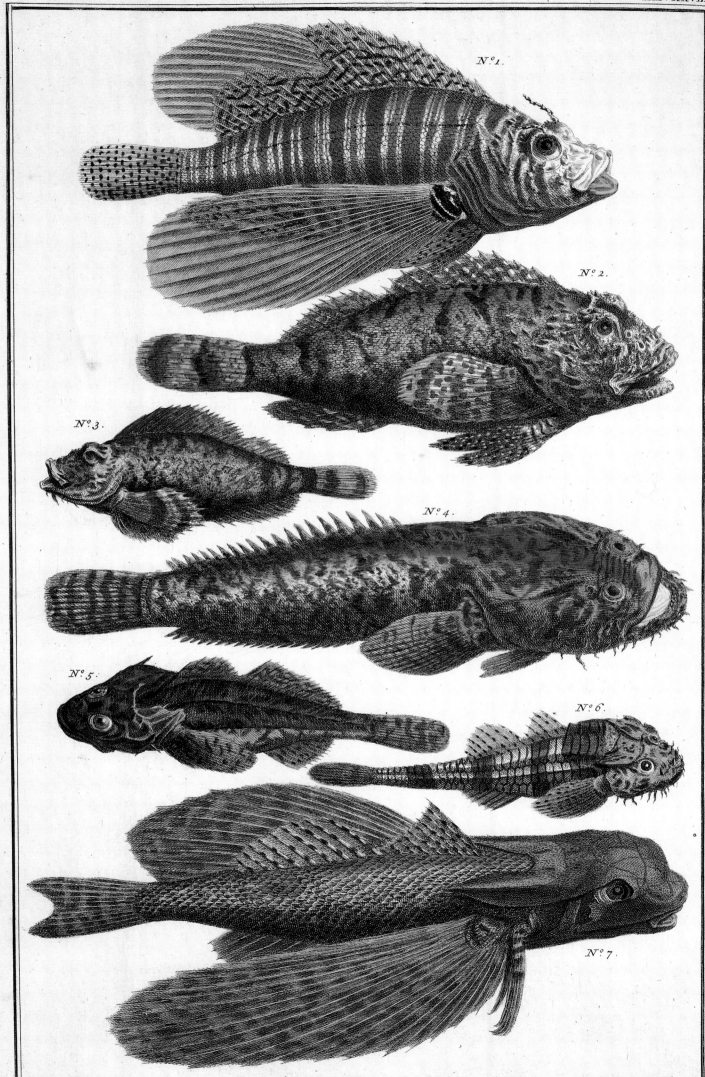

Nº 1.

Nº 2.

Nº 3.

Nº 4.

Nº 5.

Nº 6.

Nº 7.

P. Tanjé fecit 1736.

Shrimpfish, Lionfish and Frogfish

SHRIMPFISH, LIONFISH AND FROGFISH. Hand coloured engraving, pl. 7 from Decade 7 of P. J. Buc'hoz's *Première Centurie de Planches Enluminées*, 1775–81. Size of plate 12¾" × 8".

Pierre Joseph Buc'hoz was active during the second half of the eighteenth century when the natural sciences were still as much the playthings of dilettanti as the serious preoccupations of scientists. Judging from his numerous publications he was a versatile but not very discriminating populariser of botany and zoology. The book from which this plate has been reproduced has virtually no text, its stated purpose being to illustrate the rarest, most remarkable and most interesting phenomena of the three kingdoms of nature. Presumably it was aimed at those who collected curious and rare animals, plants and minerals and books about such objects.

This is one of the few illustrations of fish in the book and there can be little doubt the figures were copied from those in other publications, such as those of Albert Seba and Louis Renard which had appeared some years earlier. The frogfish and lionfish appear elsewhere in our book but the shrimpfish does not and is worth noticing here. One of four species in the Indo-Pacific region, it is also known as the razorfish because the whole body resembles the blade of a cut-throat razor, the sharp edge being along the ventral side (or underside). The body lacks scales but is encased in bony plates which extend to a sharp spike at the rear end. Some species are associated with long-spined sea urchins and swim head down among the spines, the sharp spike at their own rear end uppermost. This head-down posture seems to be normal even when the fish is not in close contact with sea urchins.

Pl. VII.

Decad. 7.

Fig. 1.

Fig. 2.

Fig. 3.

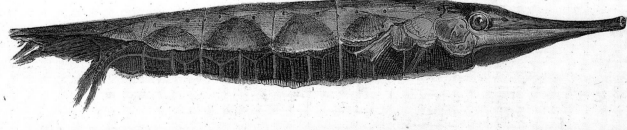

Moorish Idol and two other Exotic Fish

MOORISH IDOL, *Zanclus canescens* (top), and two other Exotic Fish. Hand coloured engraving, pl. 8 from Decade 4 of P. J. Buc'hoz's *Deuxième Centurie de Planches Enluminées*, 1778–81. Size of plate 13″ × 8″.

It is possible that Louis Renard's curious book *Poissons, Écrevisses et Crabes*, published in 1719, provided the inspiration for these engravings. They have something of the same quality of the illustrations in the earlier work and by 1778 two editions of Renard's book were available for anyone to plagiarise. Pierre Joseph Buc'hoz was a prolific author, but most of his publications were botanical in nature and do not suggest that he knew anything about fish. Like Renard's illustrations his plates are fanciful but at least one of his fish is easily recognised and one of the other two is tantalisingly reminiscent of a known tropical species.

The uppermost figure undoubtedly represents the Moorish Idol, a well-known shallow-water fish from the Indo-Pacific region. The conspicuously extended snout is used to forage for food in the crevices of coral reefs. The name Moorish Idol is said to originate from a belief that the fish is revered by orientals who return it to the water if it is captured. It is a popular aquarium fish but is very difficult to keep alive.

The lower figure has so far refused to give up its identity but the central one may represent a goose scorpionfish, *Rhinopias frondosa*, another Indo-Pacific fish associated with coral reefs. What appear to be stalked eyes may be meant to be the flaps situated above the eyes of this ten-inch-long fish which also has an upwardly turned mouth as suggested by the artist: so these figures may be a little more bizarre than the fish they portray.

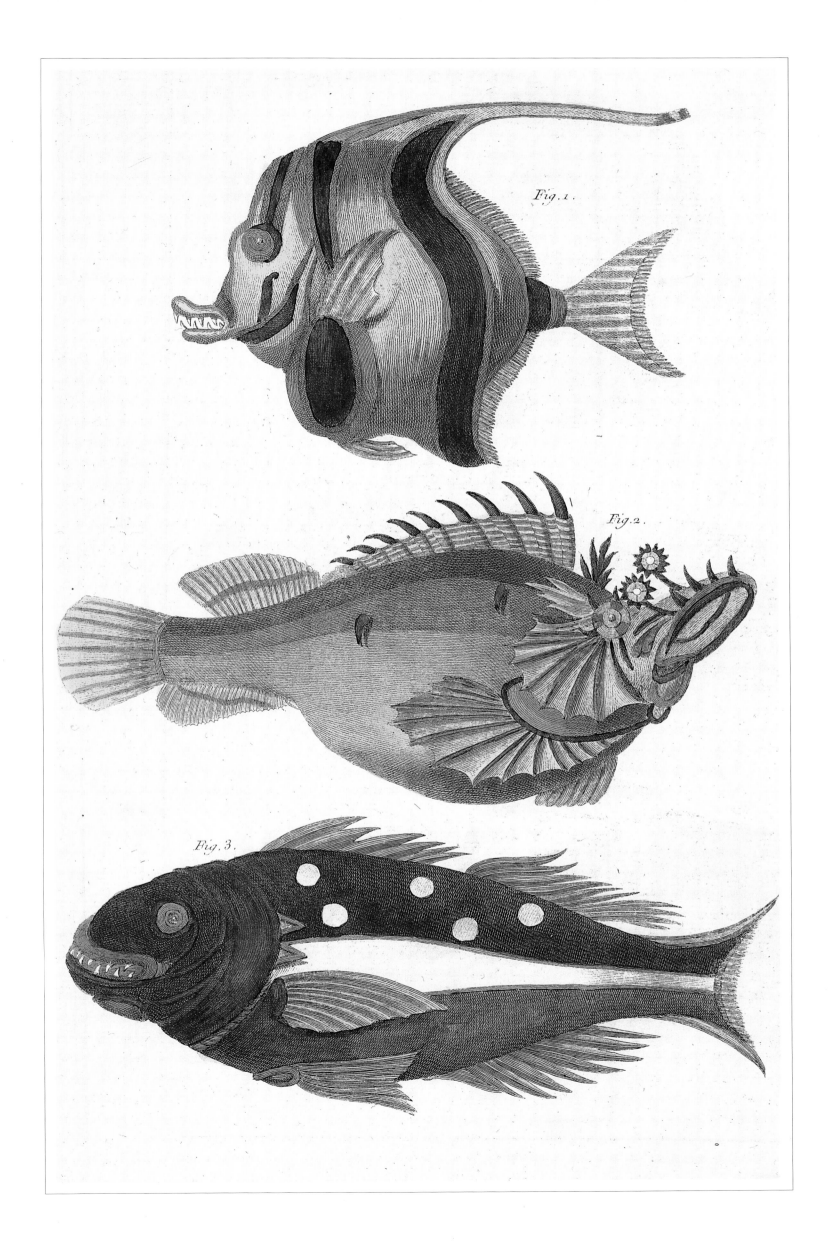

Fig. 1.

Fig. 2.

Fig. 3.

Mirror Carp

Cyprinus macrolepidotus, (now Mirror Carp, *Cyprinus carpio*). Hand coloured engraving, pl. 41 from Carl von Meidinger's *Icones Piscium Austriae,* 1785–94. Size of plate 15″ × 9″.

For two millennia the carp has been cultivated for food. Originally its distribution was limited to that part of Asia which lies between Manchuria and the rivers running into the Black Sea. It was introduced into much of Europe, probably by the Romans, and became widespread there, especially during the Middle Ages. It is now common throughout Europe and has become a major pest in the United States. An inhabitant of lakes and rivers with slow-flowing or stagnant water, it is very resistant to adverse conditions, such as water with a low oxygen content, and is not fussy about what it eats, animal or vegetable.

Domestication and selective breeding have produced a variety of differently scaled forms, of which the mirror carp is one. It gets its name from the enlarged mirror-like scales on its flanks and along its back. There are also some domesticated coloured varieties, highly prized as pets, which may change hands among hobbyists for large sums of money.

Baron Carl von Meidinger's folio publication is a magnificently illustrated record of the fish occuring in Austria during the eighteenth century. The carp is still an important food fish there and elsewhere in Europe.

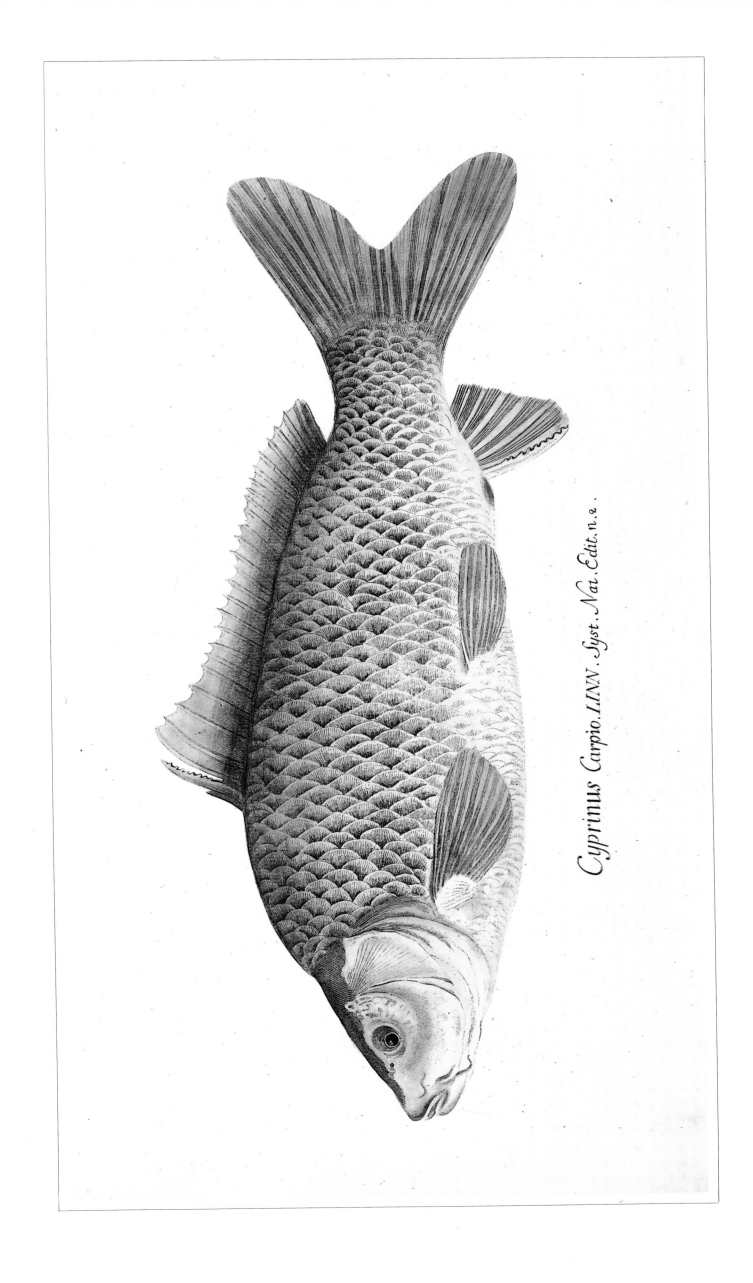

Cyprinus Carpio. LINN. Syst. Nat. Edit. n. 2.

Sargassum Frogfish

AMERICAN TOADFISH, *Lophius histrio* (now Sargassum Frogfish, *Histrio histrio*). Hand coloured engraving by Krueger, pl. 111 from Marcus Elieser Bloch's *Ichtyologie*, 1785–97. Size of plate 13¼″ × 8½″.

As its name implies, this fish lives in floating mats of Sargassum weed throughout the world's tropical seas. A lurking predator, it changes colour, chameleon-like, to blend with the seaweed. The only conspicuous feature of this otherwise well-camouflaged fish is the quivering lure dangling over its capacious mouth. Small creatures are attracted by the lure and gobbled up.

Marcus Elieser Bloch is to fish what John James Audubon is to birds. The *Ichtyologie* is the most outstanding of all fish books, containing over 400 beautiful hand coloured plates; the high quality of the engraving, the meticulous attention to detail and the exquisite colouring immediately distinguish them. In this plate, however, Bloch's artist, Krueger, has included an erroneous detail by giving the fish the lure of a different species of frogfish. Probably he drew from more than one specimen and in so doing produced a composite of two species.

LOPHIUS HISTRIO.
Die Seebrete.
Le Crapaud De Mer.
The American Toad-Fish.

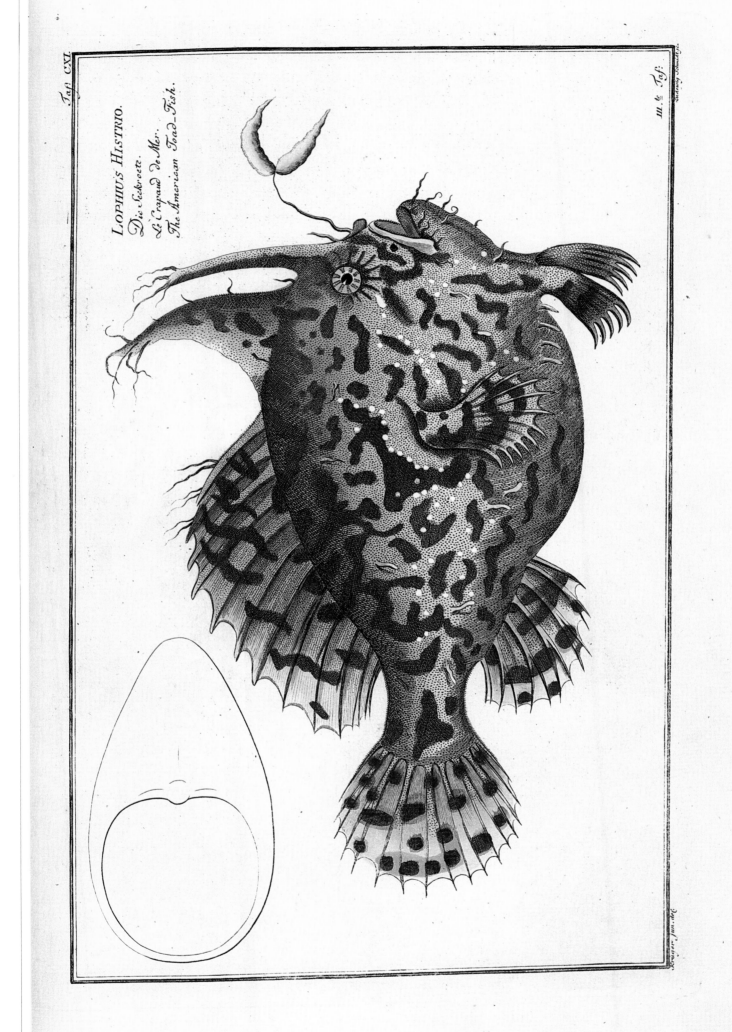

Chimaera

CHIMERA, *Chimaera monstrosa* (now Chimaera or Rabbitfish). Hand coloured engraving by Krueger, pl. 124 from Marcus Elieser Bloch's *Ichtyologie*, 1785–97. Size of plate 14″ × 7½″.

The Chimaera, in Greek mythology, is a lion-headed she-monster with a goat's body and a serpent's tail. It is not surprising that the rather grotesque fish illustrated here, with its large eyes and elongate, smooth body, should have been given such a name. Its other popular name refers to its large pectoral fins suggesting a rabbit's floppy ears and its rabbit-like head with fused teeth-plates resembling buck teeth – although here Krueger has illustrated the mouth inaccurately, arming it with triangular shark-like teeth.

This eastern Atlantic and Mediterranean fish is commonly found at considerable depths but moves into much shallower water when making inshore summer migrations. Its food is chiefly molluscs, brittle-stars and crustaceans, which it crushes between its tooth plates. In the unlikely event of one of these fishes coming into your hands, do not tamper with the venomous stout spine on its back.

The chimaera belongs to a group of about 30 species each having a gristly (or non-bony) skeleton. Unlike its relatives, the sharks and rays, its gills discharge through a single opening on either side of the head; sharks and rays have multiple gill openings. Although a very strange fish it is hardly a monster.

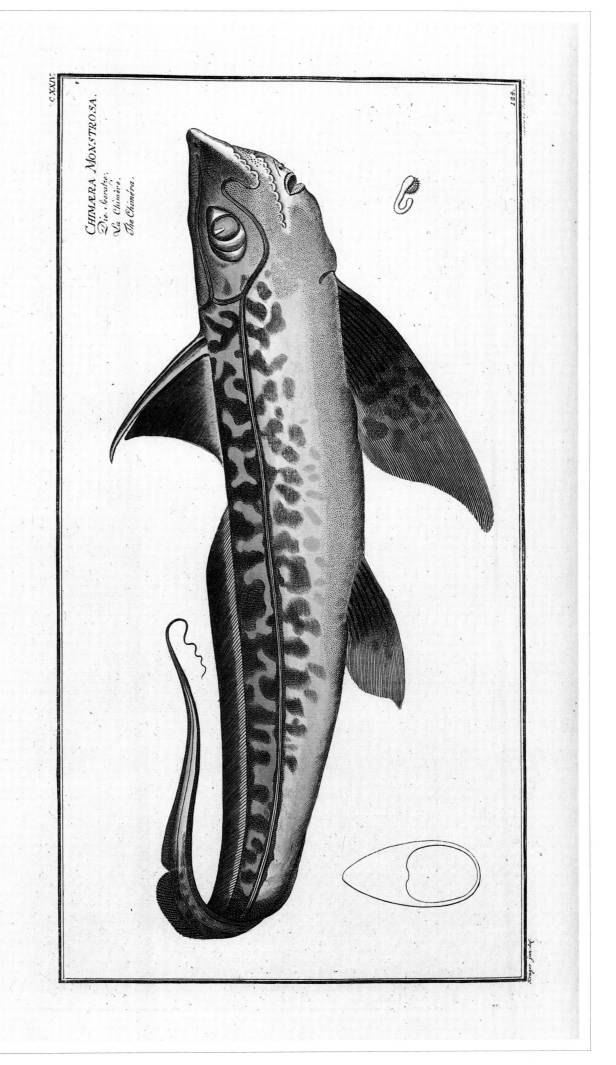

CHIMÆRA MONSTROSA.
Die Seeratze.
La Chimère.
The Chimæra.

Flying Gurnard

FLYING FISH, *Trigla volitans* (now Flying Gurnard, *Dactylopterus volitans*). Hand coloured engraving by Krueger, pl. 351 from Marcus Elieser Bloch's *Ichtyologie*, 1785–97. Size of plate 14½″ × 8″.

The most striking feature of this fish is its pair of huge pectoral fins which resemble those of the true flying fish. This superficial similarity of form deceived many early naturalists, including Bloch, into believing that the fins were used in the same way, namely to glide above the water surface. The truth is otherwise: the flying gurnard does not fly. It is a bottom dweller and too sluggish to perform such an aerial feat. Nobody is sure why it has such large fins but it has been suggested that when the fish fans them would-be predators are deterred by the sudden flash of bright colour. Alternatively, perhaps, they may be used in courtship display. They are certainly used to stir up the sand on the seabed, which probably helps the fish to uncover food such as shrimps and other small invertebrates. The flying gurnard lives in the Atlantic Ocean and usually inhabits fairly shallow water, down to about 300 feet.

This striking illustration is the crowning glory of Bloch's *Ichtyologie* and helps to show why his book is so coveted by collectors.

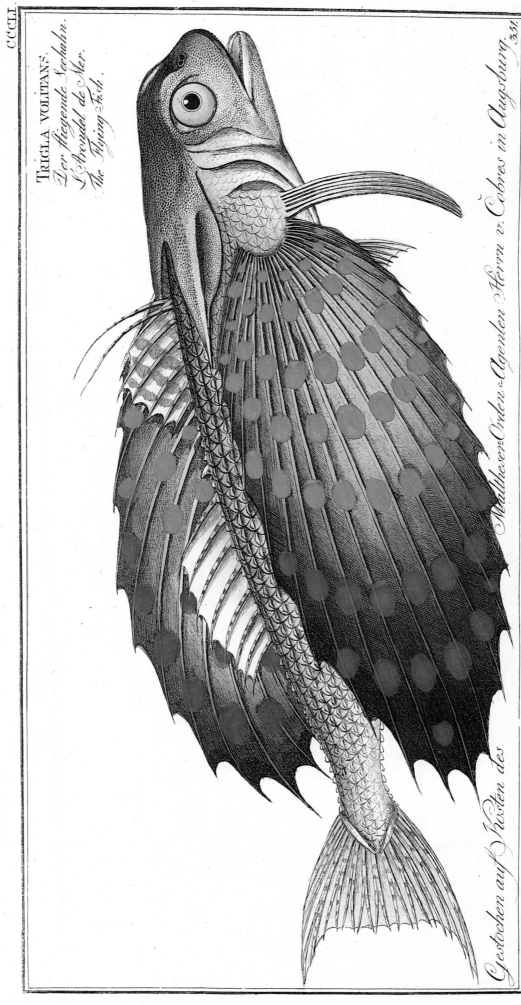

CCCLI.

Trigla volitans.
Der fliegende Seehahn.
L'Hirondel de Mer.
The Flying-Fish.

Nicolai ser Orden v Agenten Herrn v Cobres in Augsburg. 331.

J. F. Hennig sc.

Gestochen auf Kosten des

Kruger jun. del.

Old Wife

CONSTRICTED CHAETODON, *Chaetodon constrictus* (now Old Wife or Zebra-fish, *Enoplosus armatus*). Hand coloured engraving by James Sowerby, pl. 6 from George Shaw's *Zoology of New Holland*, 1794. Size of plate 9¼″ × 6¼″.

The sole member of its family, the Old Wife (a name not easily explained) is confined to the waters off southern Australia. The first westerners to see it were probably those who sailed into those waters with Captain Cook during the second half of the eighteenth century. Its singular appearance prompted George Shaw to say, in his early book on Australian zoology, that it 'differs so conspicuously from all others yet discovered, as to cause no difficulty in distinguishing it, even on the most transient view; the body contracting in diameter in a most singular manner in the middle'. Shaw, who was Keeper of Zoology at the British Museum, would have known it only as a shrivelled museum specimen or possibly as a drawing. He would have known nothing about its habits.

A common species, the Old Wife lives in moderately shallow water near rocky reefs and jetties or among seagrass meadows where it feeds on worms and crustaceans. It may swim alone, in pairs or in large schools. It almost always swims with its fins erect, very much as shown in this illustration. During daylight this ten-inch-long fish tends to remain in the shade, and at night it sleeps alone in a crevice or in a seagrass meadow. It makes an interesting aquarium fish and is also good eating.

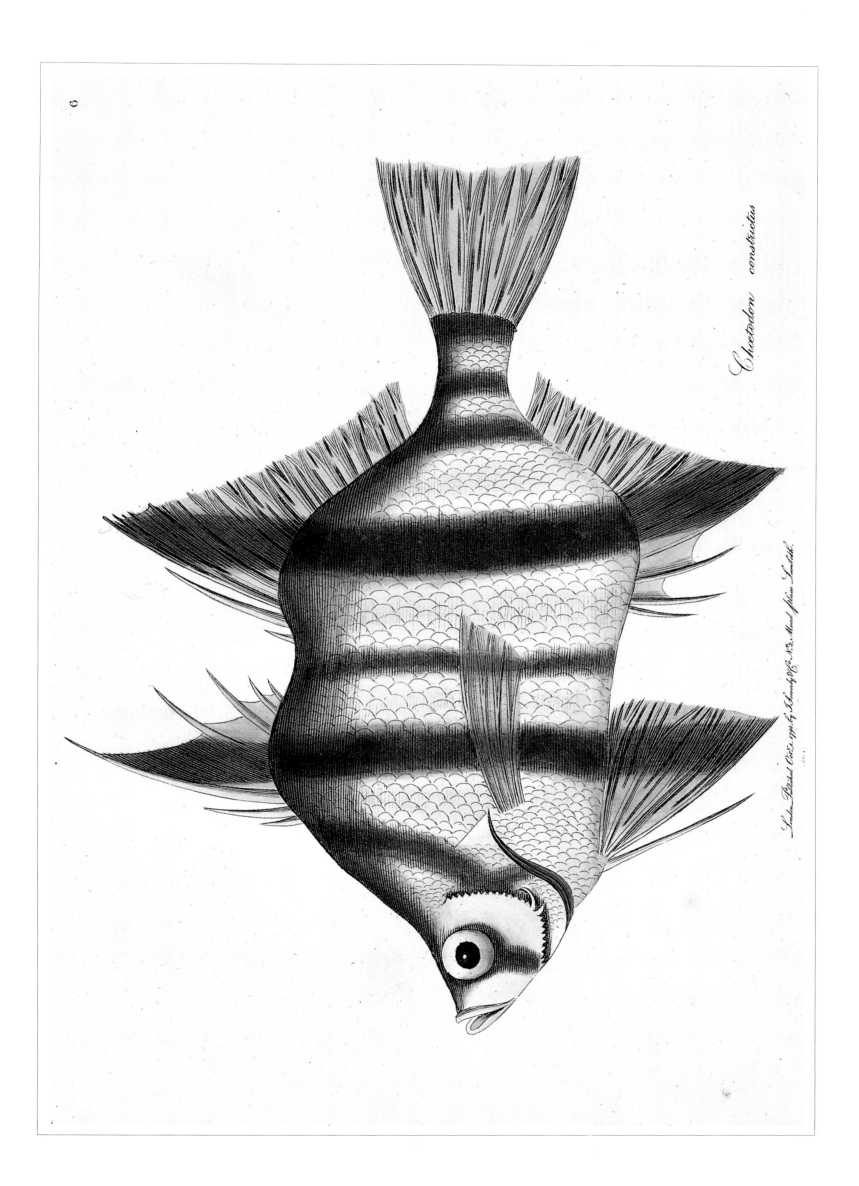

London. Published Oct.5. 1794. by I. Sowerby & Co. N.2. Mead place Lambeth.

Dragonet

SORDID DRAGONET, *Callionymus dracunculus* (now Dragonet, *Callionymus lyra*). Hand coloured engraving, pl. 84 from Vol. 4 of Edward Donovan's *The Natural History of British Fishes*, 1802–1808. Size of plate 8″ × 4¾″.

Edward Donovan's is a sad tale. In his youth he was wealthy and used much of his fortune to produce natural history books. These he illustrated with his own drawings, 'purposely made from the specimens in a recent state, and for the most part whilst living.' Although his books apparently sold well, he made little money from them and ended his days in poverty, embittered by the thought that he had been cheated by his bookseller and publishing partner.

Now greatly appreciated for their visual appeal, Donovan's works were sometimes criticised in his own day. 'Great labour has been bestowed upon the colouring of the plates he published, which renders his works expensive', so wrote William Swainson in 1840, in his *Biography of Zoologists*. 'The figures', he added, 'for the most part, are destitute of grace or correctness.'

In addition to natural history books, Donovan published an account of his travels in Wales and it was on the Welsh coast that he saw this dragonet. He wrote, 'French fishermen conceive this to be the female of the Gemmous Dragonet, *Callionymus Lyra*; they bear a remote resemblance to each other, but are, we think, certainly distinct.' In fact, the Frenchmen were right!

Opah

OPAH, or King Fish (now also Moonfish, *Lampris guttatus*). Hand coloured engraving, pl. 97 from Vol. 4 of Edward Donovan's *The Natural History of British Fishes*, 1802–1808. Size of plate 7¾″ × 4½″.

The only member of its family, the opah reaches a length of six feet and a weight of about six hundred pounds. It is an oceanic species which has been recorded from the surface down to a depth of about 1,200 feet. It lives in the warmer parts of most tropical and temperate seas, although it has been caught as far north as Newfoundland.

The red fins help to show off the striking coloration of this fish about which, for all its considerable size, we know little. The mouth, though small and toothless, is adapted for eating other fish and a variety of creatures such as crustaceans, jellyfish and molluscs. It is especially fond of squid, its stomach often being found packed tight with their beaks.

It is not often seen among a fishmonger's wares but makes good eating, the flesh being firm and similar to that of the tuna. Some recipes refer to it as sunfish but this usage may cause confusion because the same name is in regular use for a different fish.

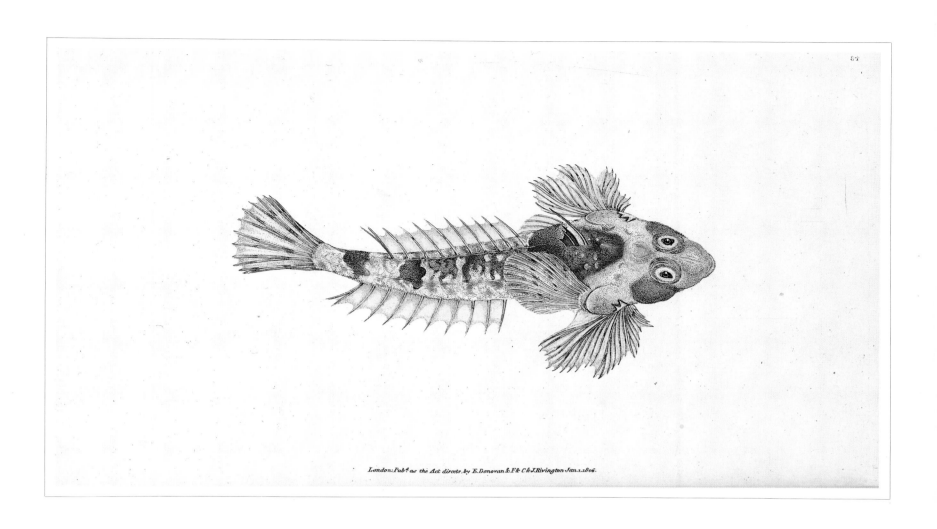

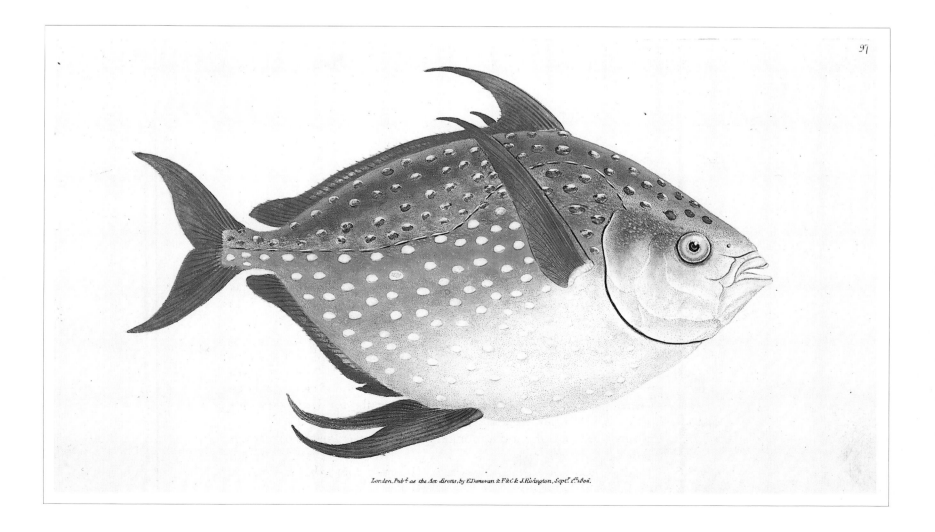

Two Surgeonfish

Apisurus elegans (now Orangespine Unicornfish, *Naso lituratus*) (top), *Acanthurus sohal* (now Sohal) (bottom). Hand coloured lithograph, pl. 16 from Eduard Rueppell's *Fische des rothen Meeres* (in his *Atlas zu der Reise im nordischen Afrika*), 1826–28. Size of plate 14¾" × 10".

Here we see two members of a group known collectively as surgeonfish, small-scaled, compressed fish living around coral reefs and in tide pools in tropical seas. They are so named because of the sharp, blade-like spines, often highlighted by bars of bright colours, which are situated on either side of the tail. In some surgeonfish, as in the orangespine unicornfish, the spines are permanently erect, while in others each spine turns forward into a sheath and is erected to form a dangerous weapon when the fish is disturbed or an aggressor tries to grasp its tail. Most of the eighty or more species are greyish-brown in colour, some are predominantly blue, and others have scarlet on the tail. The orangespine unicornfish reaches a length of about 18 inches and belongs to a small sub-group which includes species with a horn-like process protruding from the forehead; as it is one of the species which lacks that process its popular name is misleading. It is found over much of the Indo-Pacific region.

The sohal, a slightly smaller fish, has a much more restricted distribution, being found only from the Red Sea to the Arabian Gulf. An inhabitant of the outer edge of reef flats, it is very aggressive when guarding its territory.

Eduard Rueppell collected and studied the fish illustrated here during an expedition to the Red Sea undertaken for the Senckenberg Museum in 1822. As many of the fish he collected proved to be new to science he went there again in 1831 and collected many more previously undescribed species.

Tab.16.

Fig. 2

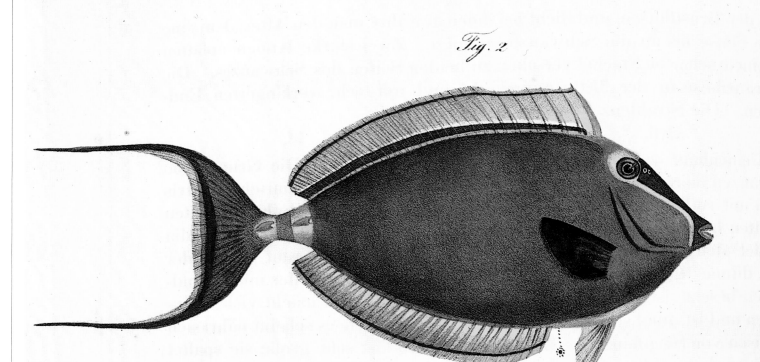

Fig. 1

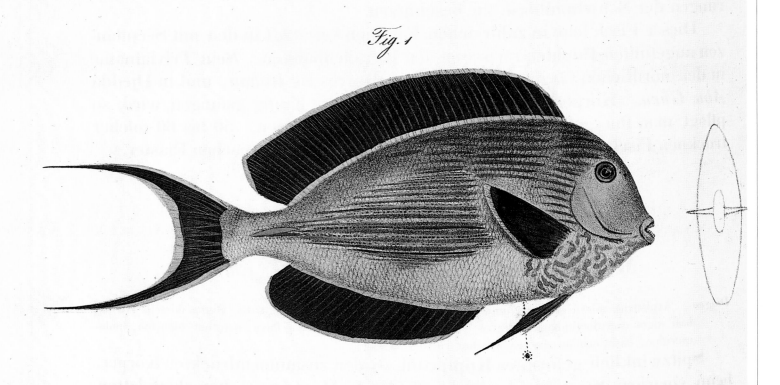

Fig. 1 Acanthurus sohal
„ 2 Aspisurus elegans

Two Frogfish

CHIRONECTE ROUGE, *Chironectes coccineus* (now Scarlet Frogfish, *Antennarius coccineus*) (top), Chironecte Marbre, *Chironectes marmoratus* (now Sargassum Frogfish, *Histrio histrio*) (bottom). Hand coloured engraving by Bevalet after original drawings by R. P. Lesson, pl. 16 from the *Atlas* to R. P. Lesson and P. Garnot's *Zoologie* (in M. L. I. Duperry's *Voyage autour du monde . . . sur . . . la Coquille*), 1826–30. Size of plate 12¾″ × 9″.

The research vessel *Coquille* set sail in 1822 on one of the series of exploratory voyages undertaken by the French during the first quarter of the nineteenth century. On board were the naturalists René Primevère Lesson and Prosper Garnot who, following their return to France, edited and partly wrote the zoological portion of the scientific report. Lesson is better known for his publications on humming-birds but he also knew a great deal about other animals, although he was not infallible when dealing with fish, as we shall see.

The scarlet frogfish frequents shallow water in the Indo-Pacific region. This engraving of it, copied from Lesson's original drawing, gives an incorrect idea of the length of the fleshy part of the tail. For many years students were deceived by this inaccurate picture and confused the scarlet frogfish with a very similar species which has a longer tail.

Although the Sargassum frogfish is illustrated elsewhere in this book it is worth comparing the two pictures to see how different artists have tackled the same subject. Its chameleon-like colour changes also ensure that no two specimens are alike. The Sargassum frogfish is known from both the Atlantic and the Indo-Pacific region, the specimen illustrated here having been collected by the naturalists of the *Coquille* at New Guinea.

1.

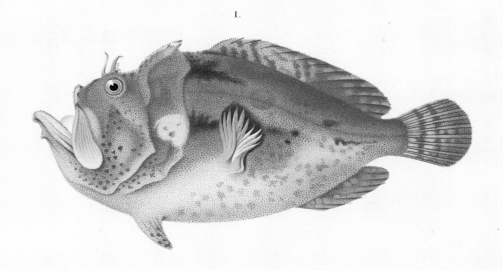

2

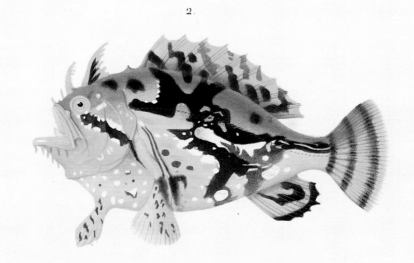

1. CHIRONECTE ROUGE. (Chironectes coccineus, Cuv.)

MERS DE L'ÎLE MAURICE.

2. CHIRONECTE MARBRÉ. (Chironectes marmoratus, Cuv.)

MERS DE LA NOUV. GUINÉE.

Bévalet pinx d'après Lesson.

De l'imp.ᵉ de Rémond.

H. Legrand sculp.

Clown Anemonefish and Squirrelfish

Amphiprion tunicetus (now Clown Anemonefish, *Amphiprion percula*) (bottom right) and two Squirrelfish, family Holocentridae. Hand coloured engraving, pl. 25 from the *Atlas* to R. P. Lesson and P. Garnot's *Zoologie* (in M. L. I. Duperrey's *Voyage autour du Monde . . . sur . . . la Coquille*), 1826–30. Size of plate 12¾″ × 9″.

When the French research vessel *Coquille* sailed into the Pacific the naturalists on board must have been amazed at the abundance of colourful fish, especially when the ship was near a coral reef. We are so used to seeing underwater colour photographs of fish swarming around coral reefs that we sometimes need to be reminded how wonderful such sights must have seemed to someone encountering them for the first time in their natural environment. We also need to be reminded that when the *Coquille* was in Pacific waters there were no face masks and no equipment allowing a human observer to see underwater clearly and for prolonged periods. What we see in such pictures as this are hand coloured engravings based on rapid watercolour sketches and notes made when the various species were caught and taken out of the water, necessarily rapid because the fish often changed colour by the minute once out of the water.

The little anemonefish with the orange and white bands around its body, one of about 26 species known, has an interesting life style. It spends most of its time amongst the tentacles of sea anemones, diving into them whenever danger threatens (it is immune to their stinging cells). Although it mainly eats algae and crustaceans it has been seen to nip off bits of the tentacles and eat them. Never found very far from sea anemones in nature it survives happily without them in aquaria. Similarly, sea anemones are able to get by without the clown anemonefish.

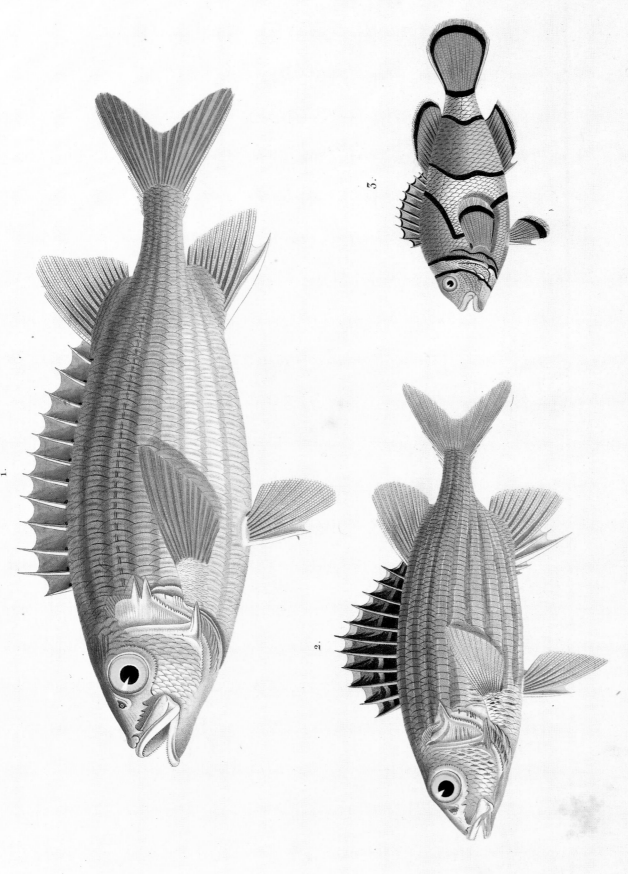

1. Holocentre tiéré. (Holocentrum tiere. Cuv. t.III. p.202) ILE D'O-TAÏTI.

2. Holocentre diadême. (Holocentrum diadema. Cuv. t.III. p. 215) ILE DE BORABORA.

5. Amphiprion tuniqué. (Amphiprion tunicatus. Cuv. t.V. p.399) MERS DE LA NOUV. GUINÉE.

Beulet pinx. d'après Lesson.

De l'imp.ie de Renond.

Schmeltz sculp.

Two Butterflyfish

CHAETODON À HOUSSE, *Chaetodon ephippium* (now Saddle-back Butterfly-fish) (top), Chaetodon seton, *Chaetodon setifer* (now Threadfin Butterflyfish, *Chaetodon auriga*) (bottom). Hand coloured engraving by Bevalet after drawings by R. P. Lesson, pl. 29 from the *Atlas* to R. P. Lesson and P. Garnot's *Zoologie* (in M. L. I. Duperry's *Voyage autour du Monde . . . sur . . . la Coquille*), 1826–30. Size of plate 13″ × 8½″.

Among the most brilliantly coloured and most numerous inhabitants of coral reefs are the butterflyfish. Small and agile, they are typically yellow or white with darker bars or streaks. Many of them have eye spots, the otherwise very conspicuous real eye often being disguised by a dark bar running through it. Many butterflyfish assume different patterns at night.

It has been suggested that a function of the vivid colours and striking patterns displayed by these nimble little fish is to mark their territories. Konrad Lorenz called them 'poster colours', an expression which well describes the advertising effect they create at a distance. It has also been suggested that these very spiny creatures display such brilliant colours and patterns to deter would-be predators. As butterflyfish are notably absent from the stomach contents of predatory fish it is probable that their bright colours have a warning function.

The saddle-back butterflyfish is widely distributed in the Pacific Ocean and in the eastern part of the Indian Ocean but is uncommon over large parts of its range. It is one of the few species that loses the dark eyeband as it gets older. The threadfin butterflyfish is not only more widespread, being found from the Red Sea to the Hawaiian Islands, but is also generally more abundant. It owes its popular name to the mobile filament trailing from its dorsal fin.

1.

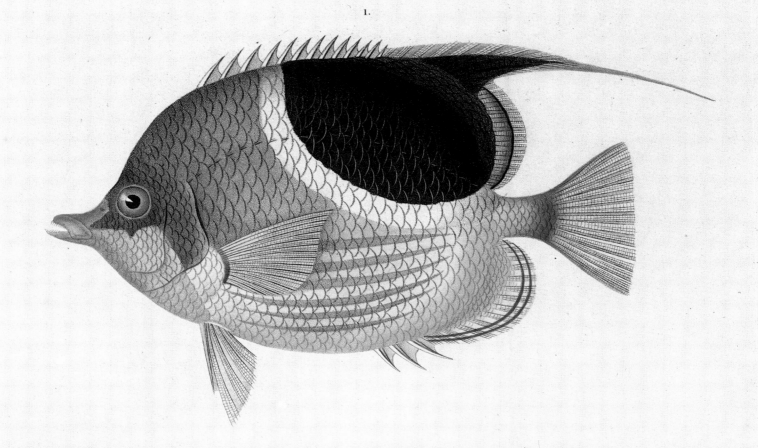

2.

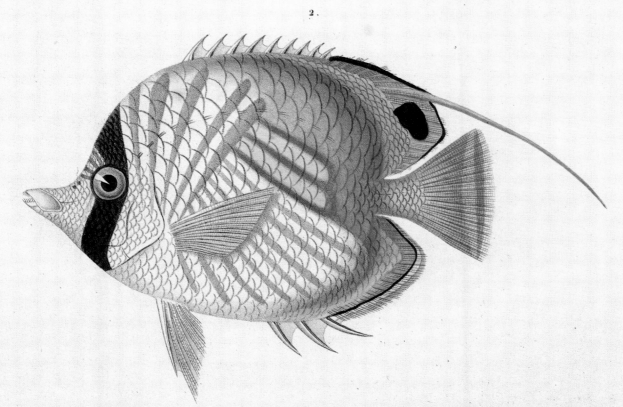

1. CHÉTODON À HOUSSE. (Chœtodon ephippium, Cuv.)

2. CHÉTODON SÉTON. (Chœtodon setifer, Bloch.)

ILES DE BORABORA ET D'O-TAÏTI.

Bévalet pinx. d'après Lesson. De l'imp.ie de Rèmond. Giraud sculp.

Smallhead Flying Fish

EXOCET À HAUTE DORSALE, *Exocoetus altipennis* (now Smallhead Flying Fish, *Cheilopogon pinnatibarbatus altipennis*). Hand coloured engraving by Anne-douche from an original drawing by de Ligniville, pl. 560 from Vol. 19 of the octavo edition of Georges (Baron) Cuvier and Achille Valenciennes' *Histoire Naturelle des Poissons*, 1828–49. Size of plate 8½″ × 5½″.

The *Histoire Naturelle des Poissons*, from which this engraving has been taken, was a huge publication, extending to 22 volumes, in which more than 4,500 different species were described. Each volume was issued in both a large and a small format, available with the plates either plain or hand coloured, the latter being nearly twice as expensive as the former.

The fast-swimming flying fish, of which there are some 60 species, evade predators by leaping clear of the water and gliding just above the surface with the help of their wing-like pectoral fins. Appropriately, the surface-skimming Exocet missile, developed by the French, takes its name from their word for the flying fish.

Long-nosed Butterflyfish

CHELMON À TRÉS LONG BEC, *Chelmon longirostris* (now Long-nosed Butter-flyfish or Forcepsfish, *Forcipiger flavissimus*). Hand coloured engraving by Pedrelli from an original drawing by Werner, pl. 175 from Vol. 7 of the octavo edition of Georges (Baron) Cuvier and Achille Valenciennes' *Histoire Naturelle des Poissons*, 1828–49. Size of plate 8½″ × 5½″.

The long-nosed butterflyfish is one of two species which form the genus *Forcipiger*, butterflyfish in which the mouth is at the tip of a long snout. A long-snouted fish was collected in the Hawaiian Archipelago during Captain Cook's third circumnavigation and was named *longirostris* by the French naturalist Pierre Broussonet. Cuvier and Valenciennes, outstanding authorities on fish, believed the specimen illustrated here was identical, not realising their specimen belonged to another species. Their book, for many years the standard text on the world's fish, was so influential that, for over a century, many specimens of *flavissimus* were misidentified as the much rarer *longirostris*.

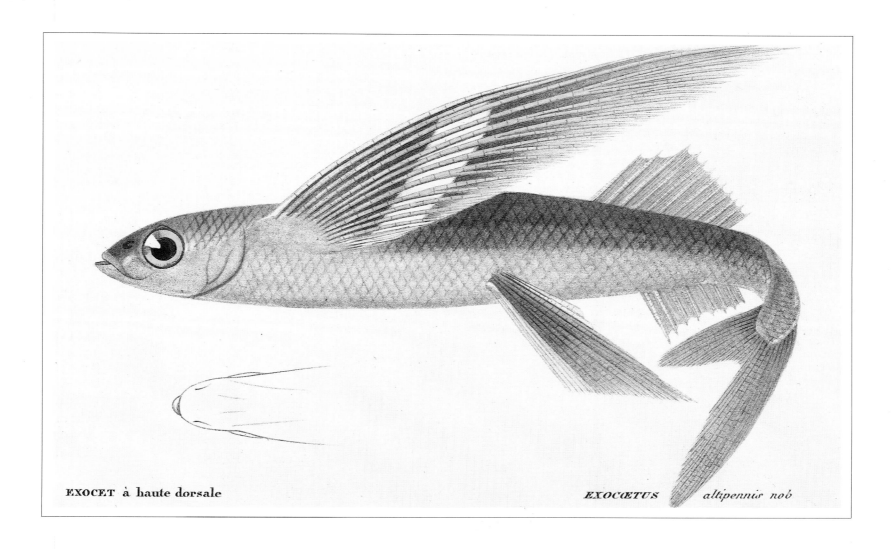

EXOCET à haute dorsale *EXOCŒTUS* *altipennis* noб

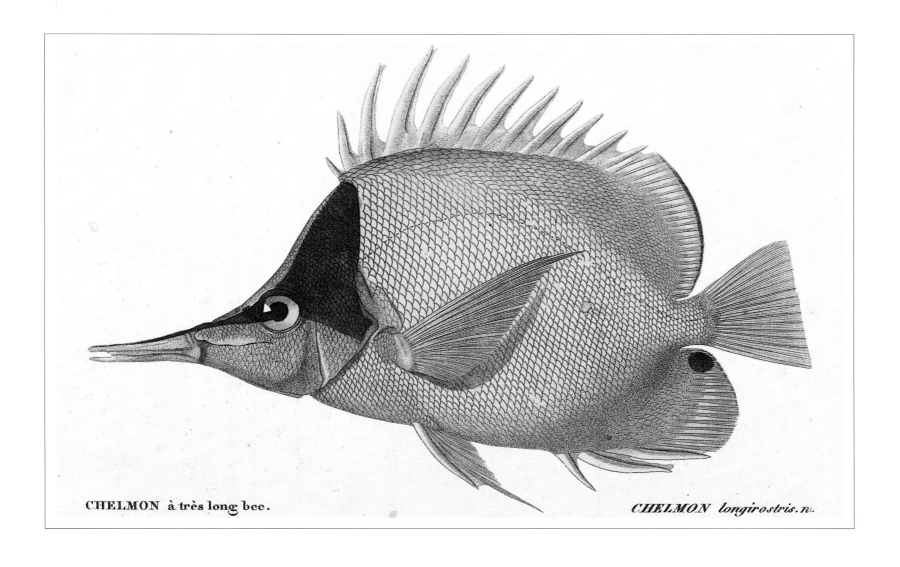

CHELMON à très long bec. *CHELMON* *longirostris.* n.

Man-eating Piranha

Serrasalmo pirainha (now Piranha or Man-eating Piranha, *Serrasalmus piraya*). Hand coloured lithograph, pl. 28 from J. B. Spix's *Selecta Genera et Species Piscium*, 1829. Size of plate 15″ × 10½″.

It was Theodore Roosevelt, the former American President, who did much to introduce the idea of piranhas as man-eaters to the developed world. He spread alarming stories about them, including one of a man being skeletonised after having fallen from his horse while crossing a Brazilian stream. Later, when the South American exploits of Percy Fawcett became known through the publication of the book *Exploration Fawcett* by his son Brian, such stories gained a new impetus. But the piranha's reputation as an insatiable devourer of human flesh is undeserved.

Students of fish behaviour who have travelled widely in those parts of South America where piranhas are known to occur almost all agree that instances of humans being bitten by them are very rare. It seems that the only time when a piranha is likely to be dangerous is when it becomes trapped because the level of its river has dropped. Then it may become ravenous and, having eaten any fish around, will attack other creatures, including mammals – and possibly humans.

The piranha has interlocking teeth in its jaw with which it can take chunks out of other fish, or even mammals. This early picture of a piranha shows that it is well equipped with strong, large teeth. When a tooth is replaced all the adjoining teeth on one side of the jaw are also replaced. This species, one of about 20 or more different kinds of piranha inhabiting the fresh waters of South America, is confined to the basin of the Rio Sao Francisco and attains a length of about a foot.

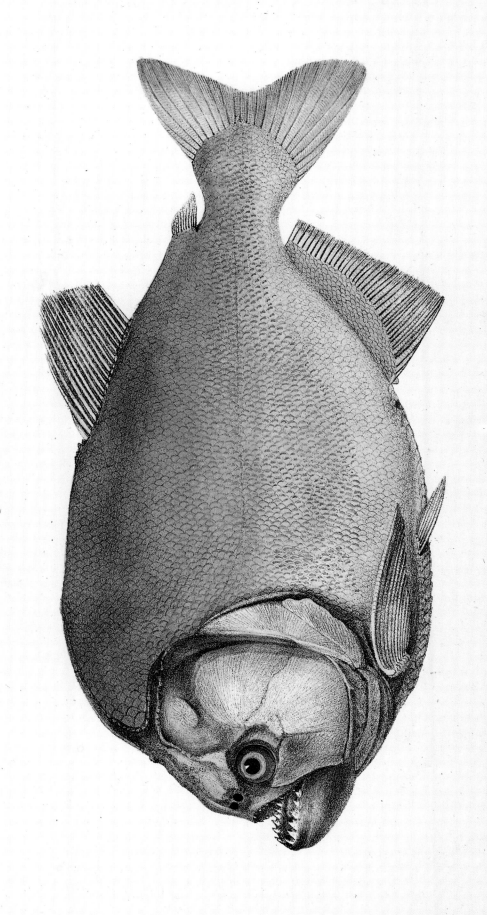

SERRASALMO Pirainha.

Tab.XXVIII.

Rock Bass

BRONZED CENTRARCHUS, *Centrarchus aeneus* (now Rock Bass, *Ambloplites rupestris*). Hand coloured lithograph by Benjamin Waterhouse Hawkins, pl. 75 from Part 3, *Fish*, of John Richardson's *Fauna Boreali-Americana*, 1829–37. Size of plate 10¾″ × 8″.

The specimen illustrated here was collected at Penetanguishene on Lake Huron during Franklin's second polar expedition. Richardson showed it to the great French naturalist Baron Cuvier, the original describer of *Centrarchus aeneus*, who confirmed the identification.

The rock bass is one of about 30 species in the family Centrarchidae, small freshwater fish known collectively as sunfish (not to be confused with the oceanic sunfish of the family Molidae). They live in a wide range of habitats, from still ponds and lakes to the flowing waters of streams and rivers throughout much of North America.

Yellow Perch

YELLOW AMERICAN PERCH, *Perca flavescens* (now Yellow Perch). Hand coloured lithograph by Benjamin Waterhouse Hawkins, pl. 74 from Part 3, *Fish*, of John Richardson's *Fauna Boreali-Americana*, 1829–37. Size of plate 10¾″ × 8″.

John Richardson was not only one of the most distinguished fish biologists of his day but was also famous as an Arctic explorer. After graduating in medicine from Edinburgh University he served as surgeon and naturalist on two expeditions to the Canadian Arctic led by Sir John Franklin. On the second of these he collected the fish illustrated here which, he said, 'has a close resemblance to the river Perch of Europe. Our specimen was taken in Lake Huron, where it frequents steep banks and affords much sport to the angler from the eagerness with which it snaps at bait.' This north-eastern fish has remained popular with anglers and has been introduced into suitable waters as far south as California and Texas.

Plate 75.

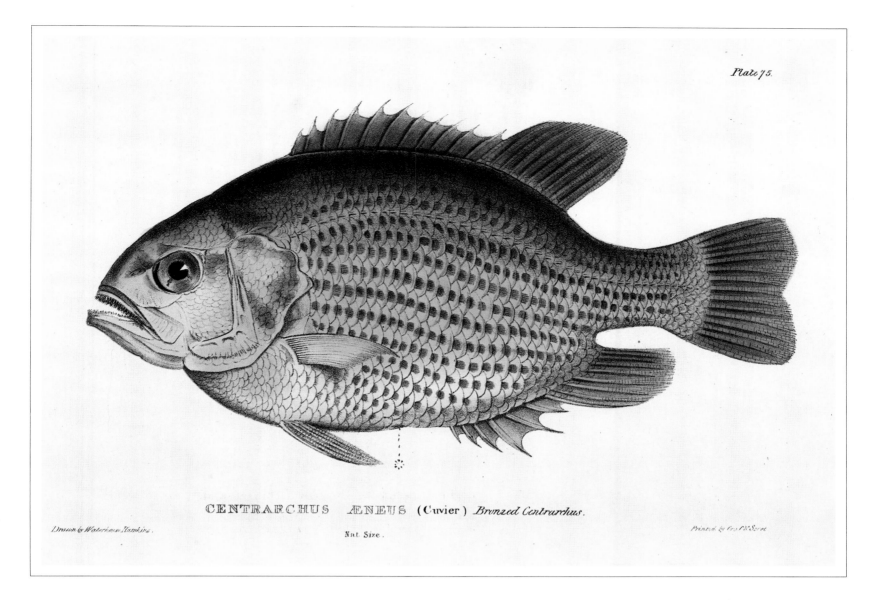

CENTRARCHUS ÆNEUS (Cuvier) *Bronzed Centrarchus.*

Nat. Size.

Drawn by Waterhouse Hawkins. Printed by Geo. P.S. Street

Plate 74.

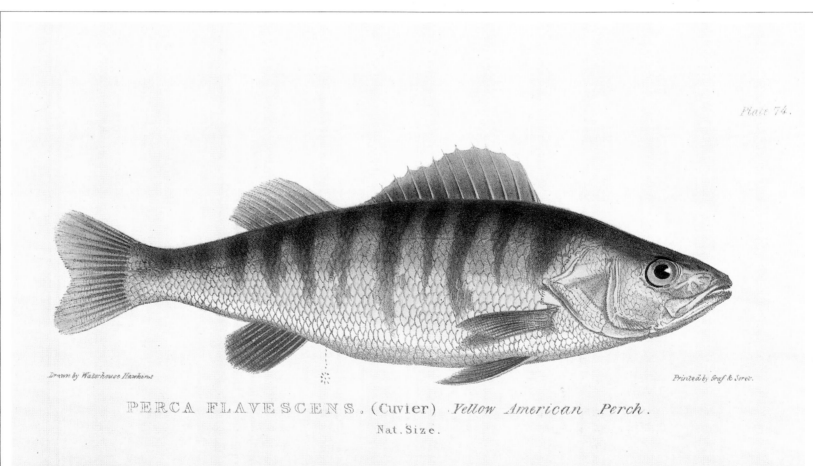

PERCA FLAVESCENS, (Cuvier) *Yellow American Perch.*

Nat. Size.

Drawn by Waterhouse Hawkins Printed by Graf & Soret

Lionfish

Scorpaena volitans, (now Lionfish or Turkeyfish, *Pterois volitans*). Hand coloured lithograph, pl. 1 from John Whitchurch Bennett's *A Selection of the . . . Fishes found on the Coast of Ceylon*, first edition, 1830. Size of plate 12″ × 9″.

The lionfish is related to the scorpionfishes and is widespread in the Indo-Pacific region. The bright reddish-brown and white stripes and the long fin spines give it a very distinctive appearance. But those vivid markings constitute a warning to would-be predators; they say 'Keep away – I'm lethal!' The tips of the long spines supporting the upper fins are venomous, as they are in the scorpionfishes. The warning coloration is directed towards those animals who would see the fish as a tasty morsel; but it should also be heeded by humans as its sting may be very painful. When threatened this fish erects the spines and swims, head down, with its dorsal spines pointing towards the source of the threat. If provoked it strikes forward with these spines. Itself a predator, the lionfish is about fourteen inches long when mature. Like many lovely objects in the natural world it is best admired at a distance.

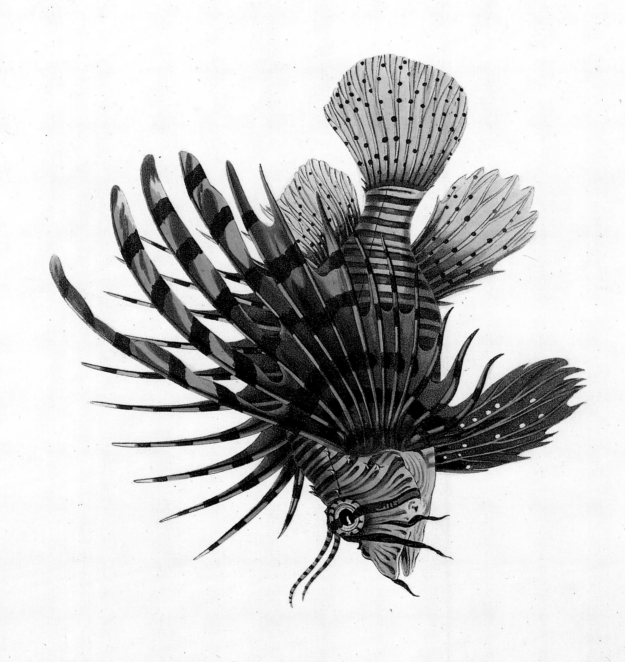

Blue-spotted Ribbontail Ray

Trygon ornatus, (now Blue-spotted Ribbontail Ray, *Taeniura lymma*). Hand coloured lithograph by William Hawkins, pl. 99 from Vol. 1 of John Edward Gray's *Illustrations of Indian Zoology*, 1830–35. Size of plate 18″ × 12½″.

This picture shows all the essential external features of a stingray. One of about 90 stingray species, this Indo-Pacific fish attains a length of some six feet and a width of about three feet. It is common in shallow water around coral reefs, often seeking the shelter of overhangs.

Like other stingrays it carries on the upper side of its tail a vicious weapon, a large, barbed and venomous spine, clearly seen in the illustration. Used for defence, it may inflict serious and sometimes fatal wounds. By raising the sting and striking forwards and downwards in the manner of a scorpion it is powerful enough to drive the sting deeply into the body of an assailant. Many injuries have been sustained by fishermen who have handled these fish carelessly and by those who have trodden on them while wading.

Illustrations of Indian Zoology is a collection of plates, based on original drawings by local artists, acquired by General Thomas Hardwicke while serving in India. John Edward Gray of the British Museum selected the plates for this book, which has no text.

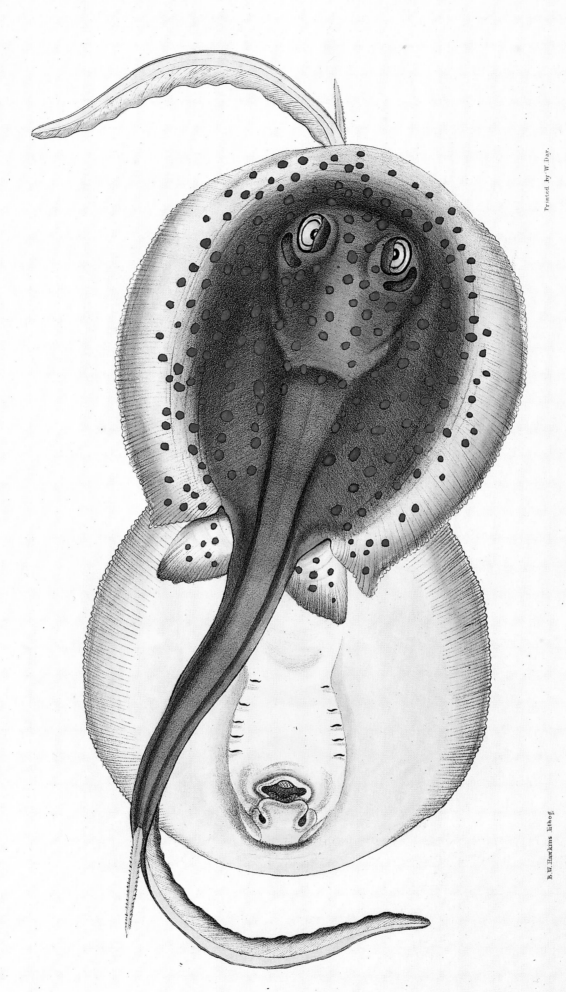

B.V. Hawkins lithog.

Printed by W. Day.

T R Y G O N Œ R N A T U S. n.

Singapore

Published 1829 by Parbury Allen & Co. Leadenhall Street.

Four Sea Bass

YELLOW-EDGED LYRETAIL (second from top), *Variola louti*, and other Sea Bass. Hand coloured engraving by Bevalet, pl. 3 from the *Atlas* to J. R. C. Quoy and J. P. Gaimard's *Poissons* (*Zoologie*, Vol. 3, in M. J. Dumont d'Urville's *Voyage de . . . l'Astrolabe*), 1830–35. Size of plate 15¾" × 10½".

In the early years of the nineteenth century the French Government sponsored a series of exploratory voyages to the Pacific, each of which had the services of one or more trained naturalists. Their duty was to bring back to the natural history museum in Paris collections of animals and plants which could be described and illustrated by them and other naturalists. The most important and most successful of these voyages was undertaken between 1826 and 1829 in the *Astrolabe* (a vessel which, as the *Coquille*, had returned in 1825 from an exploratory voyage around the world). The *Astrolabe*'s naturalists, J. R. C. Quoy and J. P. Gaimard, paid particular attention to animals which had been largely ignored by their predecessors in the Pacific, and the published report on fish was far superior to anything of the kind which had appeared up to that time. The illustrations by Bevalet, based on drawings by Quoy, are superb by any standards.

The species shown here came from various parts of the Pacific and all are members of the *Serranidae*, a large family variously known as sea bass, rock cod or groupers. The fish second from the top is the yellow-edged lyretail, a predatory grouper of coral reefs which reaches a length of nearly two feet.

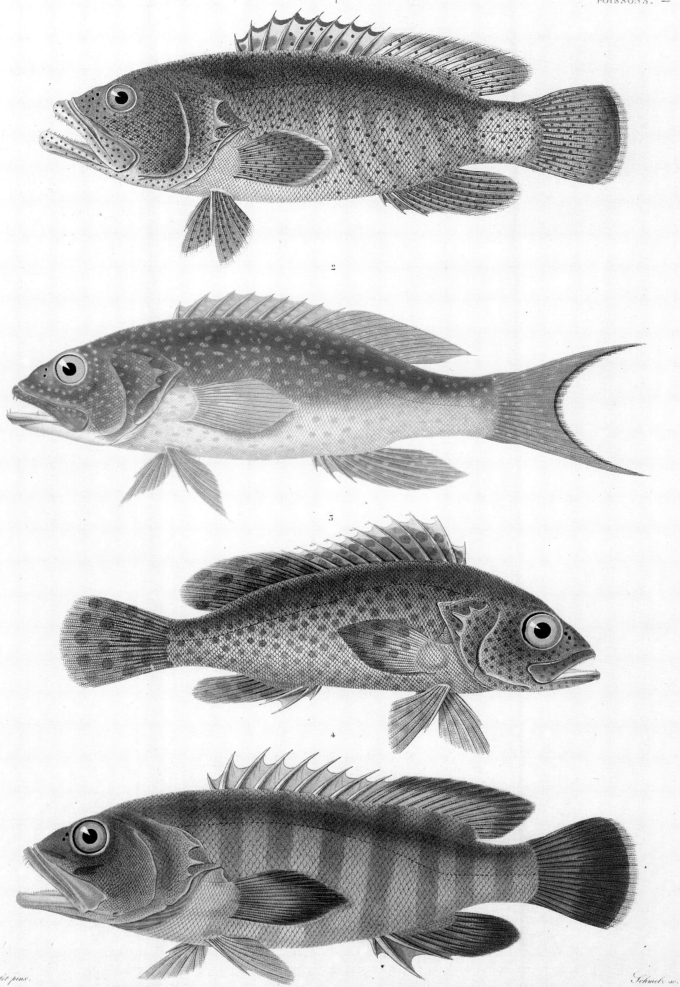

J. Tastu édit.

1 MÉROU MILLE-ÉTOILES. (NOUV.-GUINÉE) 3 MÉROU GAIMARD (NOUVELLE-GUINÉE)

2 MÉROU MOUCHETÉ. (NOUV.-IRLANDE) 4 MÉROU BOELANG. (DÉTROIT DE LA SONDE)

Fanvueil imp.

Scorpionfish and Turkeyfish

SEBASTE DU CAP, *Sebastes capensis* (now False Jacopever) (top), Scorpène de la Nouvelle Guinée, *Scorpaena novae-guineae* (now New Guinea Scorpionfish, *Scorpaenopsis novaeguineae*) (second from top), Pterois zèbre, *Pterois zebra* (now Zebra Turkeyfish, *Dendrochirus zebra*) (bottom right) and others. Hand coloured engraving by Bevalet, pl. 11 from the *Atlas* to J. R. C. Quoy & J. P. Gaimard's *Poissons* (*Zoologie*, Vol. 3, in M. J. Dumont d'Urville's *Voyage de . . . l'Astrolabe*), 1830–35. Size of plate 15¾″ × 10½″.

The main purpose of the voyage of the French research vessel *Astrolabe* in the late 1820s was to explore little known parts of the Pacific Ocean: but during the voyage it called at the Cape of Good Hope, which is how the fish which later became known as the false jacopever comes to be represented at the top of this illustration. The others were collected from the waters around New Guinea.

All the fish shown here belong to the very extensive scorpionfish family, Scorpaenidae. Members of this family are spiny and most are about a foot in length, or smaller, but some are nearly three feet long. Several have poison glands associated with the long fin spines and should be handled carefully. The zebra turkeyfish is one of the most strikingly patterned fish in the sea, its appearance in life making even the most exquisite coloured engraving look drab.

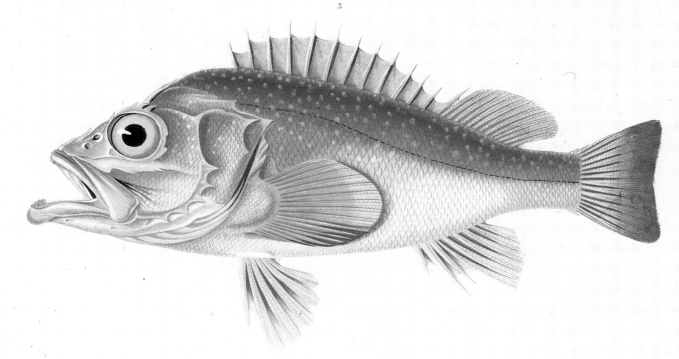

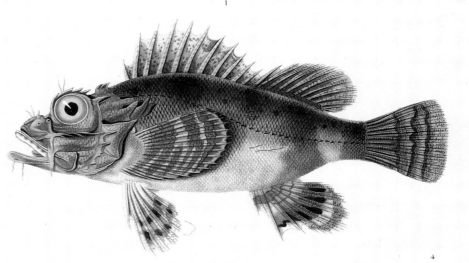

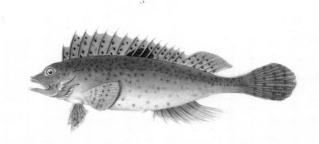

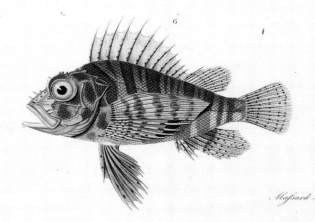

1 Scorpène de la Nouv. Guinée (Nlle GUINÉE)

2 Scorpène de l'île de Strong (ILES CAROLINES)

3 Sébaste du Cap (CAP DE BONNE ESPÉRANCE)

4 Apiste à longue épine (AMBOINE)

5 Apiste brun verdâtre (AMBOINE)

6 Ptéroïs zèbre (NOUVELLE-GUINÉE)

J. Tastu edit.

Duménil imp.

Squirrelfish

VARIOUS SQUIRRELFISH, family Holocentridae. Hand coloured engraving by Bevalet, pl. 14 from the *Atlas* to J. R. C. Quoy and J. P. Gaimard's *Poissons* (*Zoologie*, Vol. 3, in M. J. Dumont d'Urville's *Voyage de . . . l'Astrolabe*), 1830–35. Size of plate 15¾″ × 10½″.

When Jean R. C. Quoy and Joseph P. Gaimard sailed around the world in the *Astrolabe* the islands of the Pacific, then almost untouched by naturalists, provided them with a wealth of animals and plants, many of them new to science. The series of volumes in which their discoveries were described are among the most magnificently illustrated of all expedition reports. The illustrations of fish have never been excelled and must surely have been based on colour notes and sketches made just after the specimens they portray had been taken out of the sea.

Although the top two squirrelfish shown in this engraving are widespread they are not abundant. The two naturalists found the top one at the small island of New Ireland in the Bismarck Archipelago and the one below it at the very large island of New Guinea. The latter fish is full grown at about nine inches, the former at about fourteen inches.

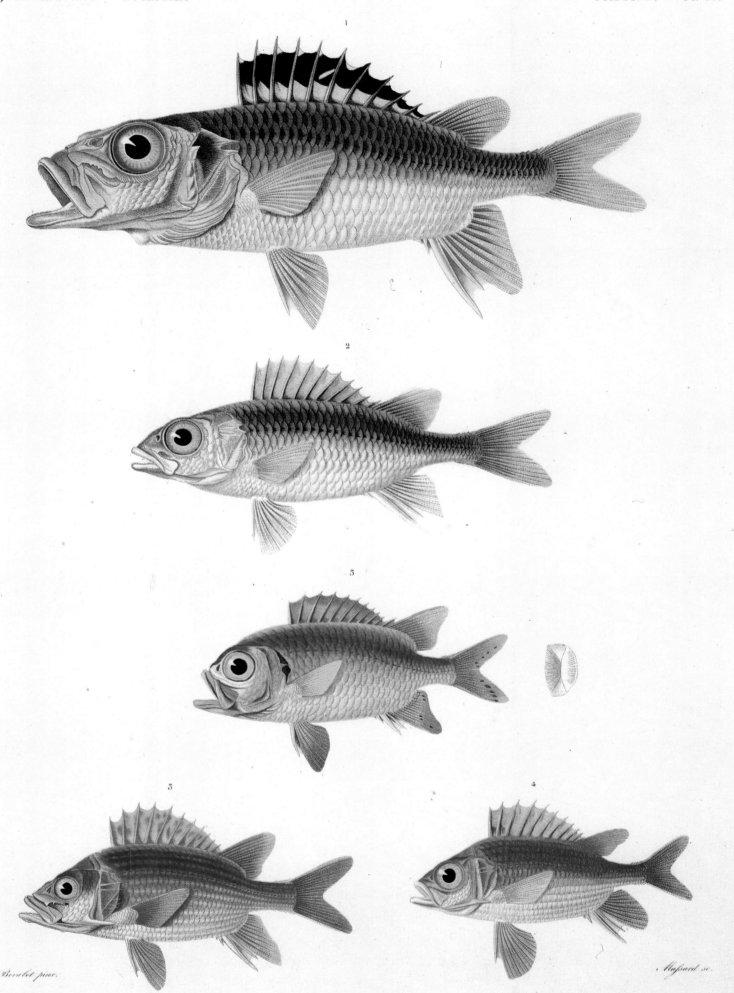

Bevalet pinx.

Massard sc.

1 Holocentre operculaire (NOUV. IRLANDE) 4 Holocentre double tache (NOUV.-GUINÉE)

 3 Holocentre lion (VANIKORO)

2 Holocentre argenté. (NOUV.-GUINÉE) 5 Myripritis hexagone BOUROU

J. Tastu edit. Dumenil imp.

Sea Dragon

FOLIATED PIPE-FISH, *Hippocampus foliatus* (now Sea Dragon, *Phyllopteryx taeniolatus*). Hand coloured engraving by W. H. Lizars after a drawing by William Thomson, pl. 20 from James Wilson's *Illustrations of Zoology*, 1831. Size of plate 16″ × 12″.

The engraving of this extraordinary looking creature was based on an original drawing sent by William Thomson of Hobart, Tasmania, to Professor Robert Jameson of Edinburgh University. Thomson also sent Jameson the specimen he had drawn, which is now part of the fish collection of the National Museums of Scotland, a relic of an age when almost any natural object from Australasia had great curiosity value. With leaf-like appendages adorning its back, tail and abdomen, the foliated pipe-fish could hardly fail to attract the attention of an Edinburgh zoologist in the early part of the nineteenth century. James Wilson, who knew of only one other specimen in Britain (sent from Australia to Sir Joseph Banks a few years previously), was happy to include its portrait and a description of it in his *Illustrations of Zoology*.

The sea dragon, resembling a large sea-horse, may grow to a length of about eighteen inches and may be seen around the coasts of the southern half of Australia and Tasmania swimming over weed or sand in shaded areas near the fringes of reefs. The bony plates which encircle its body, together with the leafy appendages, help to break up its contours and provide it with camouflage. The long, leafy appendages of skin stream out as it swims, giving it the appearance of a floating piece of seaweed. It feeds on small shrimps in shallow water.

As in other pipe-fish and sea-horses it is the male which broods the eggs. In this species the male carries the eggs attached to the underside of his tail until they are ready to hatch.

PLATE XX.

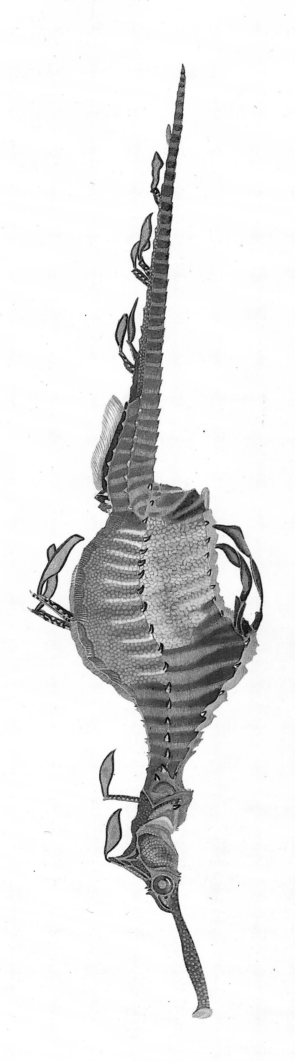

The Foliated Pipe Fish.

HIPPOCAMPUS FOLIATUS.

Drawn by Wm Thomson, Hobart Town. — Engraved by W.H. Lizars, Edinburgh.

Brown Ray

Raja quadrimaculata (now Brown Ray, *Raja miraletus*). Hand coloured lithograph by Battistelli after a drawing by Ruspi, pl. 64 from Vol. 3 of C. L. Bonaparte's *Iconografia della Fauna Italica*, 1832–41. Size of plate 14½″ × 10″.

Charles Lucien Jules Laurent Bonaparte, Prince of Musignano and Canino, had the means to indulge to the full his love of natural history and authorship. His bulky work on the Italian fauna is one of many substantial publications from his pen, several of which are graced with attractive coloured illustrations; the fish section of this work is particularly well illustrated.

Rays of the type illustrated here are distinguished from other fish by the greatly enlarged pectoral fins, the two dorsal fins and the positioning of the gill openings on the underside of the head. Instead of taking in water through the mouth, as other fish do, rays utilise two large openings on the top of the head, just behind the eyes. Known as spiracles, these structures take in water for breathing purposes while preventing the delicate gills being clogged with sand. There are many different species, some of which grow as large as four or five feet across.

The brown ray is a relatively small species at only about a foot across. Found in the Mediterranean, the eastern Atlantic and the south-west Indian Ocean it prefers shallow water down to about 500 feet, but occasionally may descend to twice that depth.

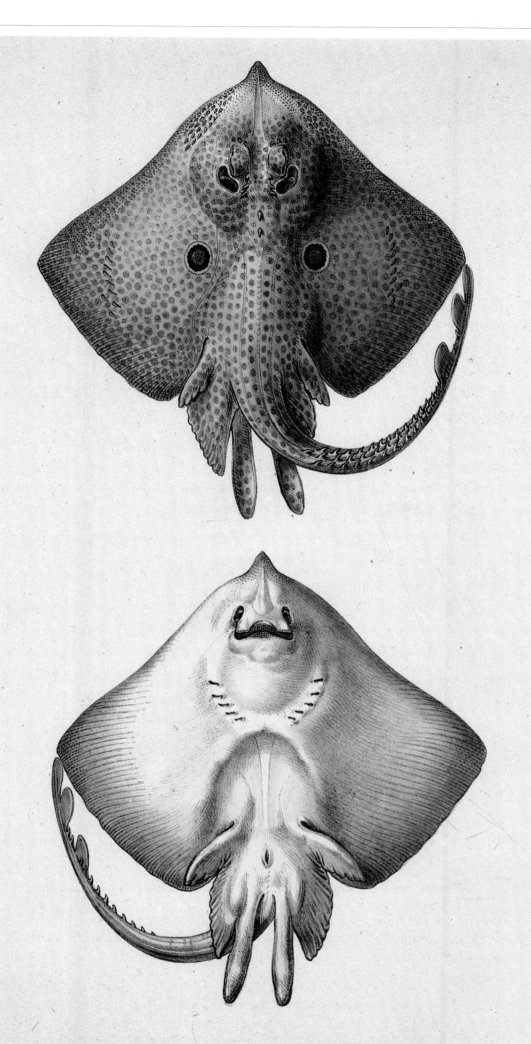

Raja Quadrimaculata Mas. ⅔

Carolus Ruspi Rom del.　　　　　　　　　　Lith. Battistelli 1833.

Great Trevally

GOROOPARWAH, *Scomber heberi* (now Great Trevally or Big-eye Kingfish, *Caranx sexfasciatus*). Hand coloured lithograph by J. Clark from an original drawing by John Whitchurch Bennett, pl. 26 from his *A Selection of the . . . Fishes found on the Coast of Ceylon*, second edition, 1834. Size of plate 12″ × 9″.

The great trevally, a large Indo-Pacific species weighing up to 40 pounds, is an important food species throughout much of its range. Bennett named it in honour of Reginald Heber, Bishop of Calcutta, who had supported Bennett's pioneering book on the fish of Sri Lanka. The book first appeared in 1830, four years after the bishop had, in Bennett's words, 'exchanged a career of every earthly good for the sublimer sphere of eternal felicity' – in other words he had died!

Yellowtail Rockcod

KAHA LAWEYAH, *Perca flava-purpurea* (now Yellowtail Rockcod, *Epinephelus flavocaeruleus*). Hand coloured engraving by J. Clark from an original drawing by John Whitchurch Bennett, pl. 19 from his *A Selection of the . . . Fishes found on the Coast of Ceylon*, second edition, 1834. Size of plate 12″ × 9″.

This is a picture of a brightly coloured juvenile, the adult being drab by comparison. Large yellowtails mostly live in the deeper parts of tropical reefs and only young ones are found occasionally in the shallows. Bennett, who was not aware he was illustrating a juvenile, considered this species 'scarce on the southern coast of Ceylon, the Author, in the course of two years having met with but one specimen.' In fact yellowtails are fairly common off the coast of Sri Lanka.

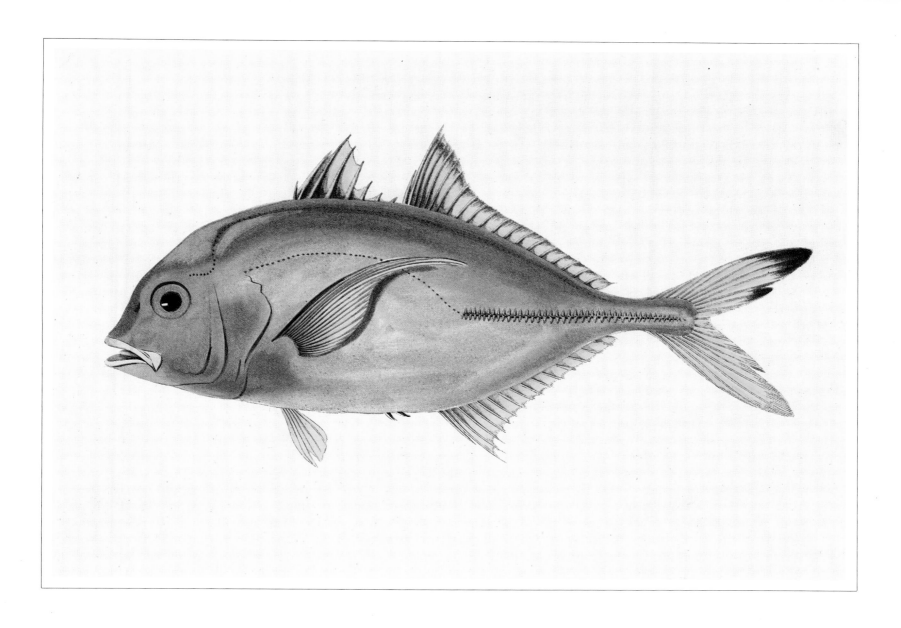

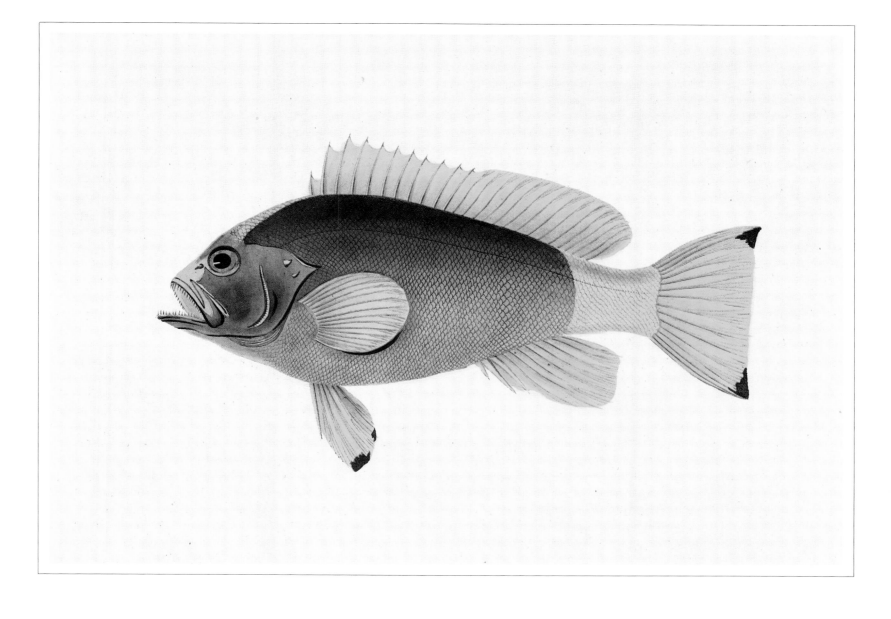

Crested Oarfish

DER LACEPEDISCHE BUSCHFISCH, *Lophotes cepedianus* (now Crested Oarfish or Unicornfish, *Lophotes lacepedei*). Hand coloured lithograph, pl. 63 from H. R. Schinz's *Naturgeschichte und Abbildungen der Fische*, 1836–38. Size of plate 13¾″ × 9½″.

Heinrich Rudolf Schinz was a first-class populariser of zoology, capable of producing beautifully illustrated books about most kinds of animals, regional or world-wide in scope. Some of his books, including that from which this lithograph has been reproduced, were not just potboilers but represented original contributions to knowledge, and the illustrations in them are mostly excellent (even though many of them must have been derived from the publications of others). Because many aspects of zoology are now so specialised it has become almost impossible for any one person to produce a string of such books.

With its ribbon-like form and prominent back fin the four-foot long crested oarfish is unmistakable, but it is more vividly coloured than the lithograph suggests. In life its back is blue and this colour becomes progressively whiter towards the underside. The body is also covered with brilliant silver spots and the fins are red or pinkish. Possibly the specimen which served as a model had faded by the time the artist began drawing it.

An inhabitant of the Mediterranean and the north-eastern Atlantic, this fish has an ink sac like that found in squid. If disturbed it discharges ink to produce an underwater smoke screen which helps it to evade predators. It is itself a predator, living off squid, anchovies and other small fish.

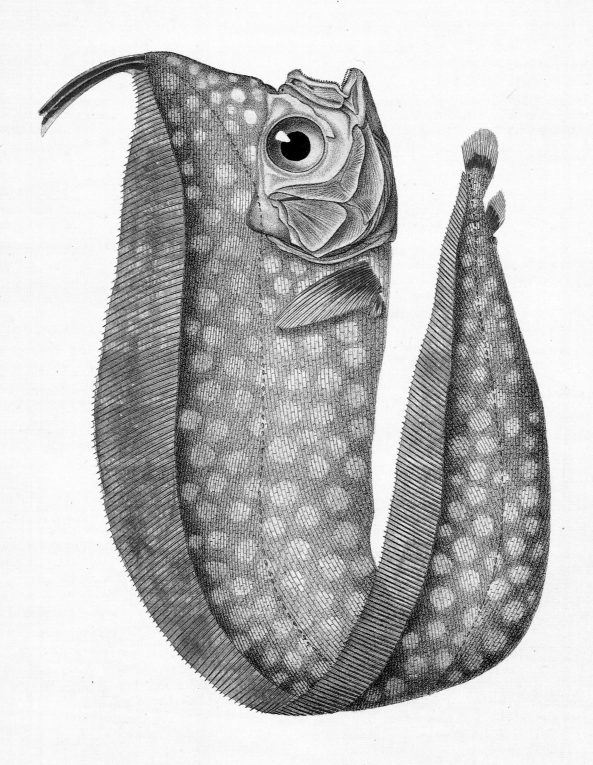

Der Lacepedische Buschfisch. Lophotes cepedianus. Lophote cépédien.

False Jacopever

Sebastes capensis (now False Jacopever, *Sebastes capensis*) (top) and *Sebastes maculatus* (now ? False Jacopever, *Sebastes capensis*). Hand coloured lithograph, pl. 22 from Vol. 3 of Andrew Smith's *Illustrations of the Zoology of South Africa*, 1838–50. Size of plate 12¼″ × 9½″.

The two fish illustrated here are now thought to belong to the same species. Their identification as two species highlights one of the problems created by the variability within many fish species. Those acquainted with the fish illustrated will have noticed that in life its colour is a pinkish red, further proof of the tendency of fish to change colour when dead or dying.

But how did it acquire the curious name false jacopever, by which it is generally known in South Africa? It was given this name to distinguish it from the true jacopever, another pinkish-red fish found off South African coasts. The story goes that a Dutch sailor named Jacob Evertsen was notorious for his drinking and for the ruddy complexion and prominent eyes which went with it. His shipmates, fancying they could see a resemblance between his face and this fish, decided to name it after him; and so it became known as the jacopever.

The author of this important multi-volume publication about the zoology of South Africa, Andrew Smith, served as an army doctor in the Cape, led several expeditions inland and became the first Superintendent of the Cape Museum. He rose to a high rank but his distinguished career was tarnished later by criticism of his handling of the provision of medical facilities during the Crimean War. Nevertheless, he was knighted subsequently.

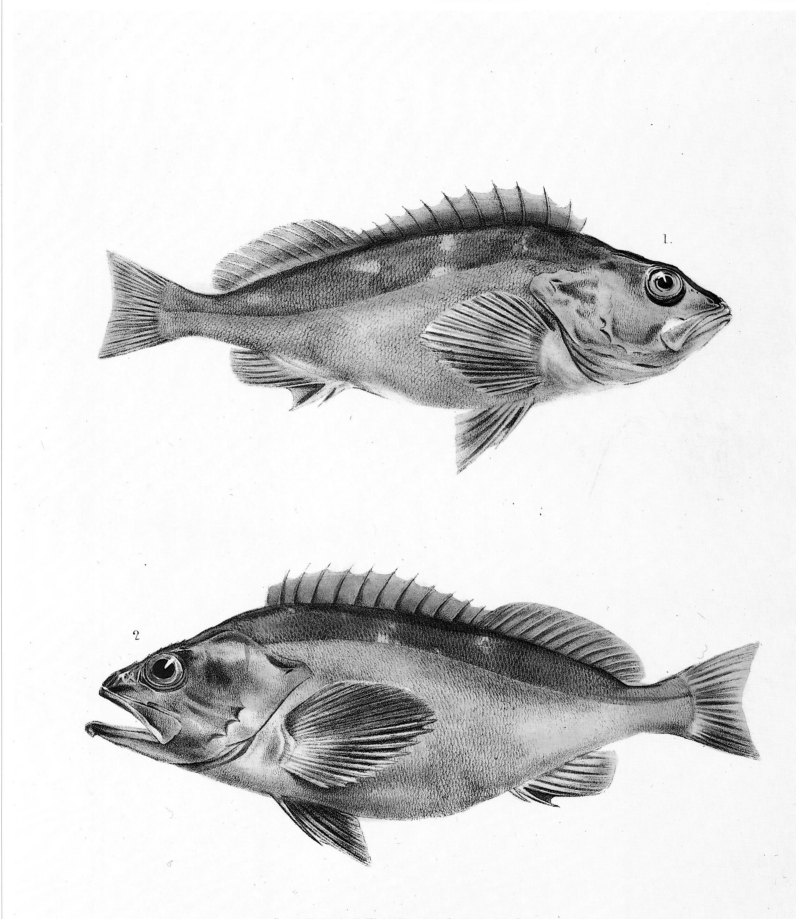

1. SEBASTES CAPENSIS.
2. SEBASTES MACULATUS.
(Pisces — Plate 22.)

Atlantic Salmon

COMMON SALMON, *Salmo salar* (now Atlantic Salmon). Hand coloured engraving by W. H. Lizars after a drawing by William Jardine, pl. 1 from Jardine's *British Salmonidae,* 1839–41. Size of plate 23¾" × 15¾".

Sir William Jardine's *British Salmonidae,* a luxury publication for a leisured few, has a larger page area than almost any other book about fish. Its first plate, as may have been expected, shows what is now known as the Atlantic Salmon at its natural size, the specimen portrayed being a male weighing two pounds thirteen ounces, caught in the Solway Firth in the month of July. The fish is shown as though stranded on a bank with a scenic view of the Solway Firth as a backdrop.

In 1653 the Atlantic salmon was described by Izaak Walton in *The Compleat Angler* as 'the king of freshwater fish'. Although it spawns and passes the first few years of its life in a river it is not strictly a freshwater fish. After its river phase it migrates out to sea and spends one or more years feeding in the northern Atlantic Ocean before returning to its river to spawn. The upstream migration to the spawning grounds is often arduous and the fish may have to surmount incredible obstacles, such as waterfalls and weirs, on the way. The returning fish may have to try evading the nets and traps of commercial fishermen as well as anglers' baits, for the Atlantic salmon has long been prized for food and sport. As river pollution has severely damaged the European stocks of this species conservation measures to preserve it have become imperative. The popularity of salmon fishing and the grace and power of the fish itself have ensured that artists have portrayed it often, but this early nineteenth-century engraving is still one of the largest and best. Jardine, who became a Royal Commissioner to the Salmon Fisheries Survey of England and Wales, was a prolific author of books about natural history, some of which enjoyed popular esteem and commercial success. His *British Salmonidae* enjoyed neither, though it is today highly regarded by those who buy and sell antiquarian books.

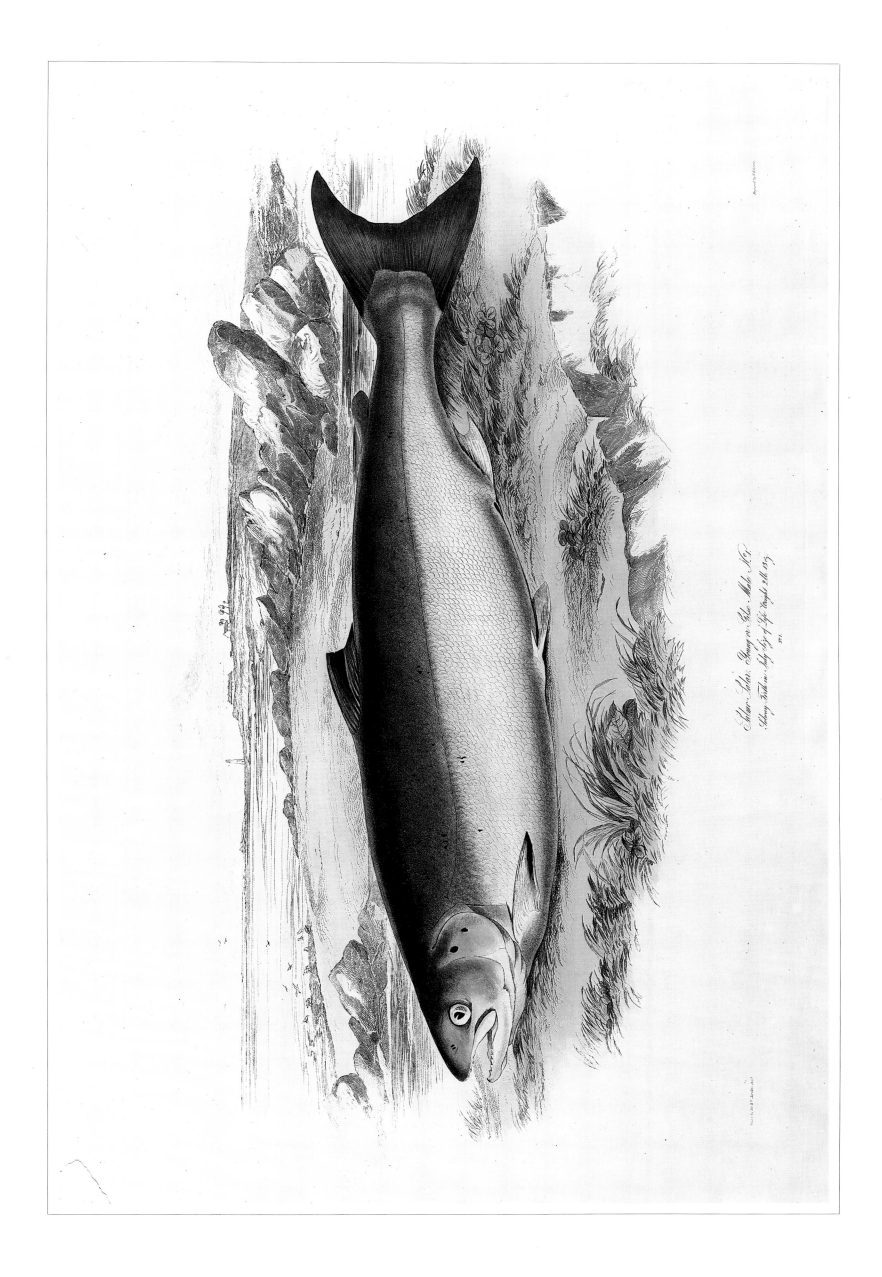

Salmon. Salar. Young or Gilse. Male. Nº 2.

Silvery Tail, in July 1843, of Life Weight 9 th 1843.

Drawn by Sir W. Jardine, Bart.

Engraved by W.H. Lizars.

Brown Trout

GREAT LAKE TROUT, *Salmo ferox* (actually a form of the Brown Trout, *Salmo trutta*). Hand coloured engraving by W. H. Lizars after a drawing by William Jardine, pl. 4 from Jardine's *British Salmonidae,* 1839–41. Size of plate 26½″ × 18″.

In the early nineteenth century it was believed that there were several different species of trout in Britain, each varying considerably in size and coloration. Fish once distinguished as the great lake trout, *Salmo ferox*, are now thought to be just one of the many varieties of the brown trout, *Salmo trutta*. Usually they were caught in the deeper parts of large lakes and were generally larger and darker coloured than examples fished from smaller lakes or streams. But, as Jardine acknowledged, the great lake form itself varies considerably. 'The fish represented on the accompanying Plate,' he says, 'is given as a remarkable variety, and not as the true state of the species. Two specimens were taken, during the month of June, in Loch Layghal, in Sutherlandshire.' The artistically drawn background scene in this engraving by Lizars shows a view of Lake Layghal.

Salmo trutta has been introduced into North America but should not be confused with the fish known there as the lake trout, which is a species of charr.

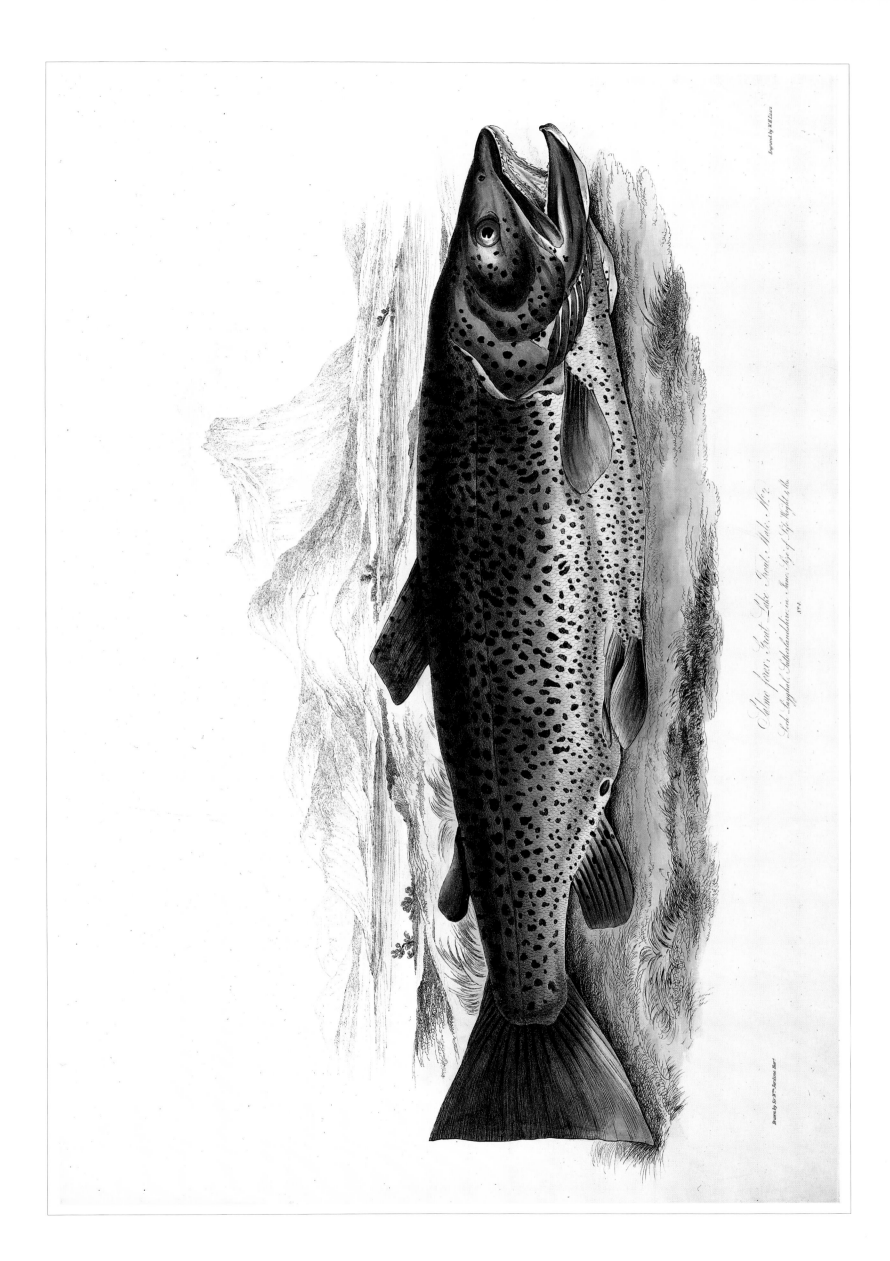

Salmo ferox, Great Lake Trout. Male. Nº 2.

Loch Laggan, Sutherlandshire in June. Nat. Size of Life. Weight 6 lbs.

Nº 4.

Drawn by Sir Wm Jardine Bart

Engraved by W.H.Lizars

Brown Trout Varieties

COMMON TROUT, *Salmo fario*, lacustrine varieties (now *Salmo trutta fario*).
Hand coloured engraving by W. H. Lizars after a drawing by William
Jardine, pl. 5 from Jardine's *British Salmonidae*, 1839–41. Size of plate
21¾″ × 16¾″.

A puzzling assortment of fish called 'trout' is found throughout Europe
and western Asia. For many years the different varieties have confused
fishermen and scientists alike and they still present some difficult puzzles. All
trout spawn in fresh water. Some spend their whole life in fresh water;
others, popularly known as sea trout, migrate to the sea. Those that live
exclusively in fresh water may occupy varied habitats, some living in rivers,
others moving downstream into lakes and returning to the rivers only to
spawn. The great variety of forms and colour patterns reflects this diversity
of lifestyles.

Previously most authorities considered that this variety showed the
presence of different species and recognised more than ten from the British
Isles alone. Now it is customary to refer all the forms to one very variable
species, *Salmo trutta*, although some recent studies suggest that the former
view may have been nearer the truth. Two forms are recognised: the
migratory or sea trout and the freshwater brown trout. The variability of the
brown trout, even among lake-dwelling forms, is well illustrated by the two
specimens shown in this engraving, both taken from Scottish lochs. The
uppermost was from Loch Assynt, the beautiful Sutherland loch shown with
the fish. The setting of the lower fish is Cladich Bay, Loch Awe, Argyll;
there, according to Jardine, 'trout of the brilliant gold colour of the
specimen, were confined nearly to the extent of the bay'.

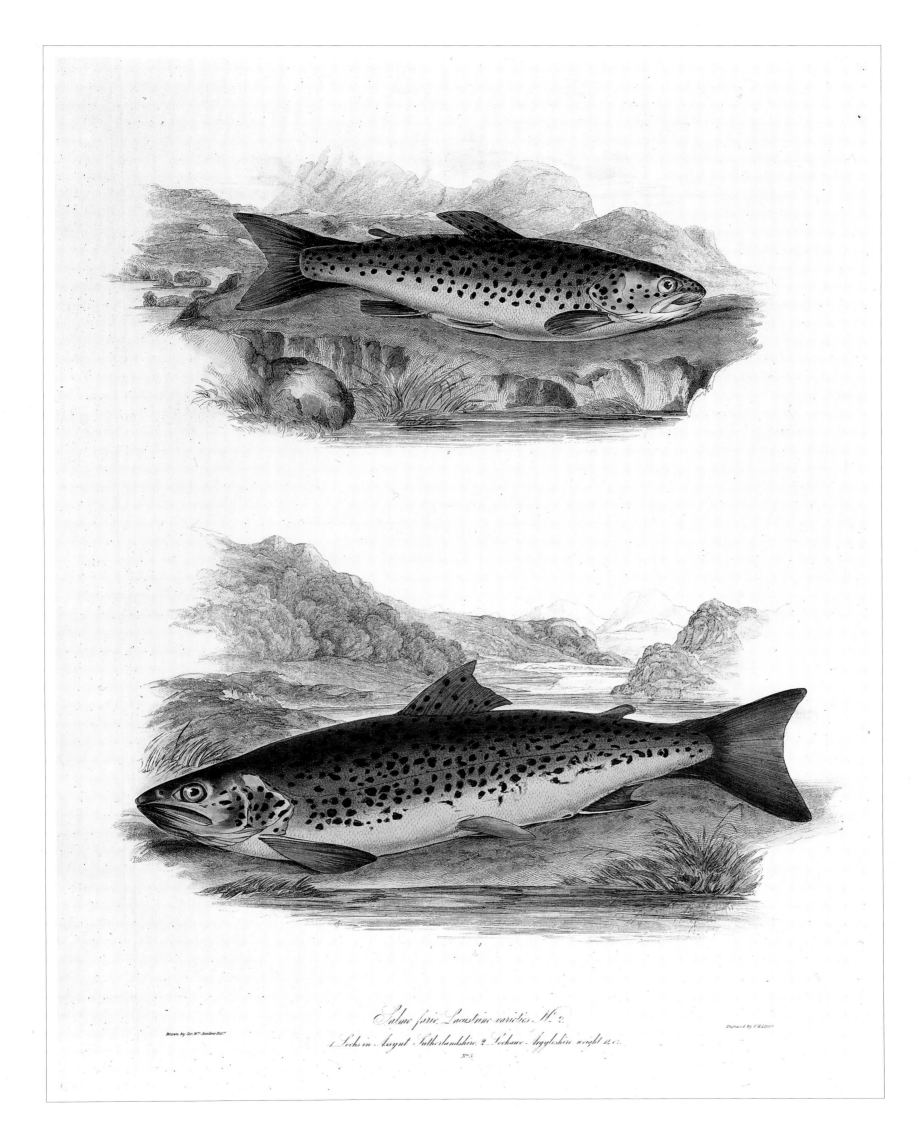

Salmo fario, Lacustrine varieties. N.º 2.

1 Lochs in Assynt Sutherlandshire. 2 Lochawe Argyleshire weight 12 c.

Drawn by Sir W.ᵐ Jardine Bar.ᵗ

Engraved by W.H. Lizars

N.º 5.

Boarfish and Golden Butterflyfish

Hypsinotus (now Boarfish, *Antigonia rubescens*) (top), and *Chaetodon aureus* (now Golden Butterflyfish, *Chaetodon auripes*). Hand coloured lithograph by J. P. Berghans, pl. 42 from Vol. 3 (*Pisces*) of P. F. von Siebold's *Fauna Japonica*, 1842–50. Size of plate 15″ × 11″.

When von Siebold was investigating the natural history of Japan in the 1820s his only source of specimens of many marine and freshwater animals would have been local fishermen, whose interest in fish would have been limited to those which gave them a living. Often, when describing a fish species in his *Fauna Japonica*, he says that he saw only a single specimen, giving an incorrect impression of great rarity. He records only a single boarfish, for instance, but this is a common fish of Japanese waters and is widely distributed in the Indo-Pacific region. It lives near the sea bottom in fairly deep water where its red colour would not be conspicuous.

Similarly, he says that he saw only one example of the golden butterflyfish, but this is the commonest butterflyfish in Japanese waters. With a length of about eight inches it is slightly smaller than the boarfish and is found in the Pacific but not in the western Indian Ocean. The colouring is typical for a butterflyfish as is the presence of a dark bar disguising the eye. Considering that von Siebold had only a single example of each of these fish it is remarkable how accurate are his paintings of them. He must have made his colour notes and sketches rapidly and skilfully, within minutes of them being taken out of the water.

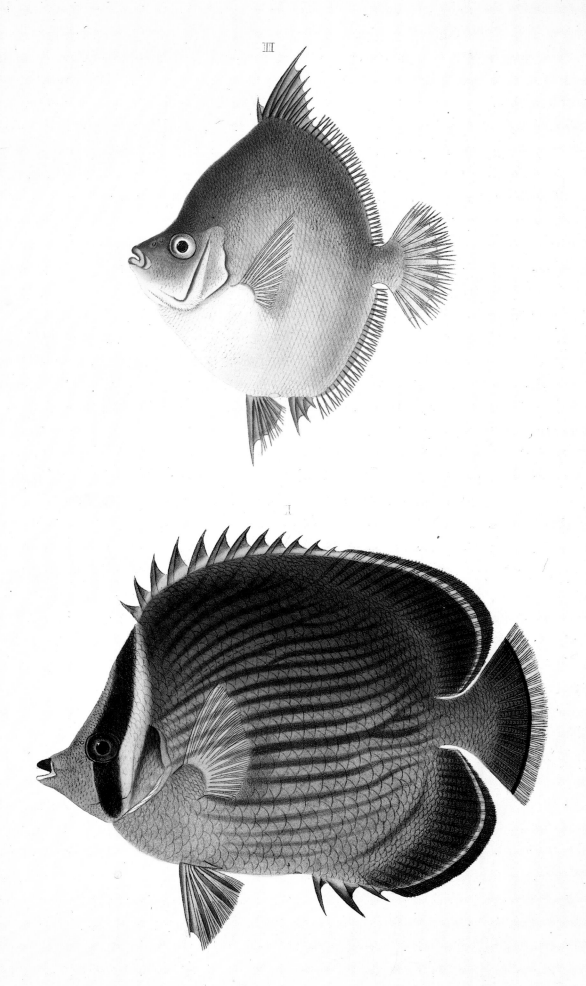

I, CHAETODON AUREUS. II, HYPSINOTUS.

Batfish

Platax vespertilio japonicus (now Batfish, *Platax orbicularis*). Hand coloured lithograph by J. P. Berghans, pl. 43 from Vol. 3 (*Pisces*) of P. F. von Siebold's *Fauna Japonica*, 1842–50. Size of plate 15" × 11".

Philipp Franz von Siebold travelled in and around Japan between 1823 and 1830, when that country was still almost a closed book to westerners. During that period he collected and observed animals and plants with zeal and discrimination. After his Japanese sojourn he planned a huge book in which his collections could be illustrated and described by specialists. The great work, edited by himself, was published in six volumes between 1833 and 1850, the third volume being devoted to fish. It is a magnificent and important treatise, magnificent because of its illustrations, important because many of the fish described were new to science.

Four species of batfish are now recognised in the Indo-Pacific region, all of them very variable but so similar that until recently they were thought to represent a single species. The problems of identification are increased by the striking contrast between the juvenile form and the adult. The juvenile batfish, as shown in this lithograph, has remarkably elongate fins above and below, but these become much reduced in the adult, which has a more rounded shape in profile. Sometimes the juveniles drift about on their sides, when they resemble floating leaves of mangrove plants or *Hibiscus*. The origin of the name batfish may be found in the shape of the juveniles' fins.

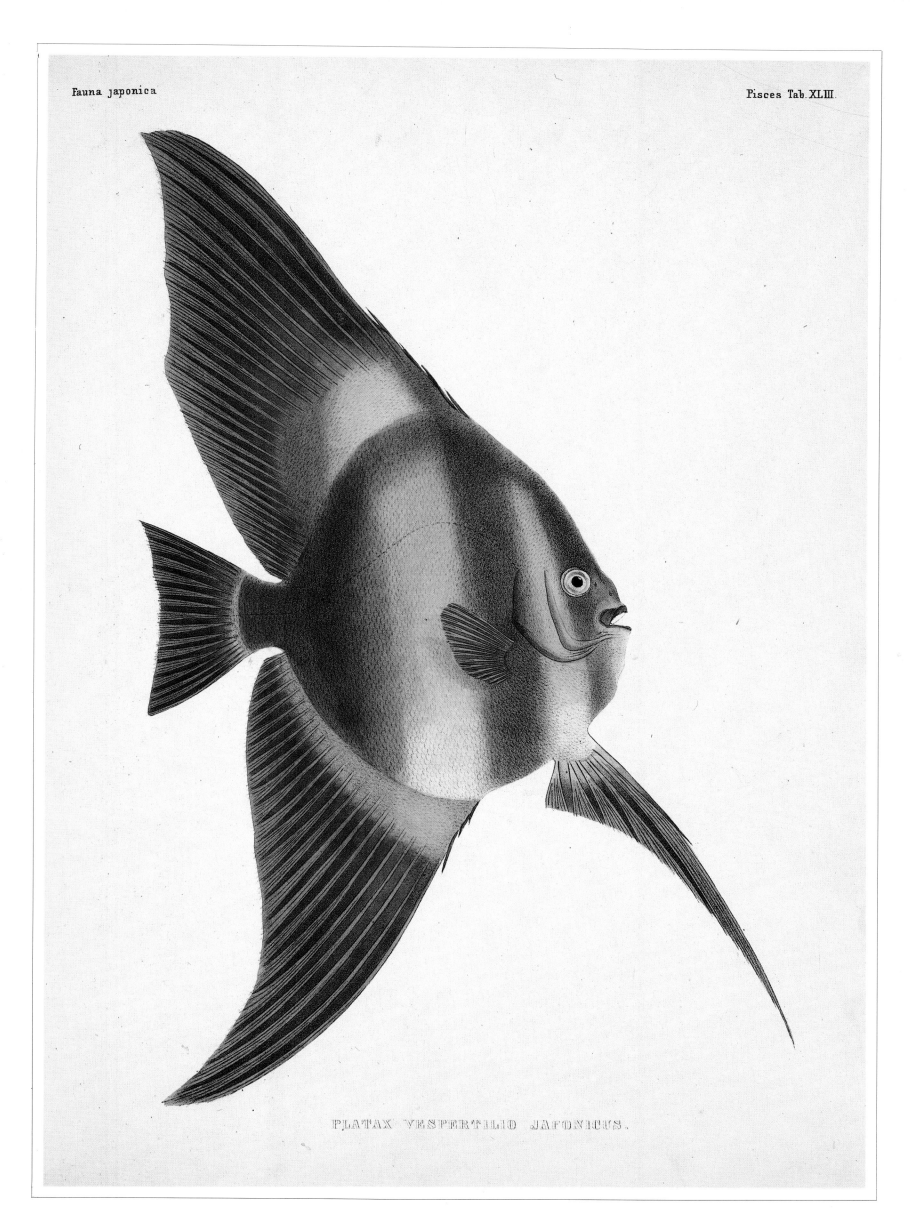

PLATAX VESPERTILIO JAPONICUS.

Ornate Wrasse

BLUE-COLLARED GREENFISH, or Swallow-tailed Wrasse, *Julis turcica* (now Ornate Wrasse, *Thalassoma pavo*). Hand coloured lithograph by C. E. Norton and M. Young, pl. 1 from Richard Thomas Lowe's *A History of the Fishes of Madeira*, 1843–60. Size of plate 10″ × 6″.

This is one of many beautiful fish found in the waters around Madeira. It is distinguished by the blue stripe around its middle, a feature conspicuous enough for the Reverend Richard Thomas Lowe to name it the blue-collared greenfish. It lives in the Mediterranean and in the eastern Atlantic, where it may be found near rocks and beds of eel grass. It is usually solitary by nature but may occur in small groups. There are about 500 different species of wrasse, most of them found in tropical or semi-tropical waters, some of them long lived, many of them brightly coloured. The most curious feature about some species of wrasse, however, is their sex life. The newly hatched members of some species, for instance, are all females; but after several spawning seasons some of them change sex. It seems that under certain circumstances they can reproduce more effectively as males, under other circumstances as females.

Rosy Soldierfish

BLACK-MOUTHED ALFONSIN, or Rough-fish, *Trachichthys pretiosus* (now Rosy Soldierfish, *Hoplostethus mediterraneus*). Hand coloured lithograph by C. E. Norton and M. Young, pl. 9 from Richard Thomas Lowe's *A History of the Fishes of Madeira*, 1843–60. Size of plate 10″ × 6″.

This fish occurs in the eastern Atlantic and the Mediterranean and is recorded from waters as far north as Ireland. An average sized example measures about eight inches in length but the species grows considerably larger in waters off West Africa. Its belly has a serrated edge and its fins are spiny, but its rosy coloration redeems its rather ugly appearance.

The Reverend Richard Thomas Lowe was the English chaplain at the island of Madeira for many years but he seems to have spent more time studying aspects of its natural history than caring for the spiritual welfare of its expatriate population. Besides his pioneering work on fishes he wrote extensively on the shells and flora of Madeira and its satellite islands. In 1874, when returning to the island after a sojourn in England, the ship in which he was travelling, the *Liberia*, was wrecked in a storm and he was drowned.

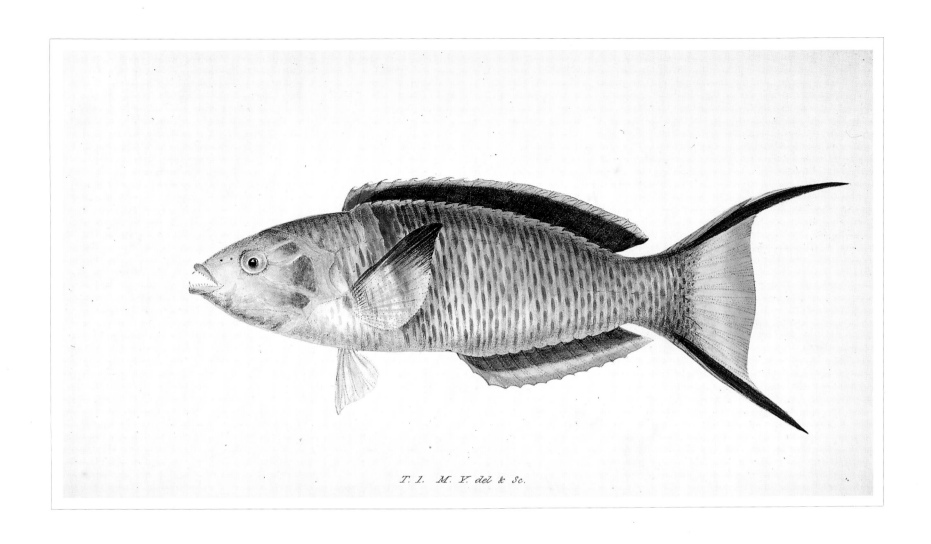

T. 1. M. Y. del & Sc.

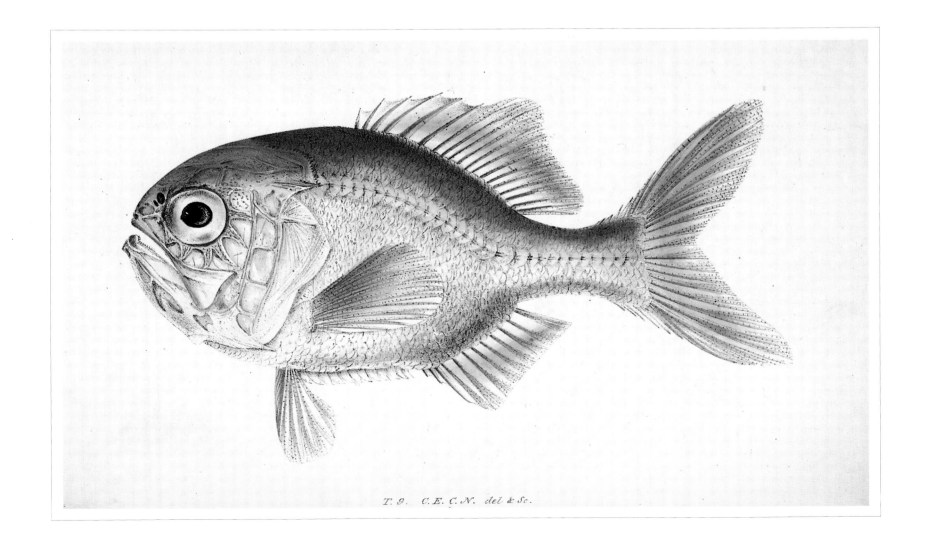

T. 2. C. E. C. N. del & Sc.

Green Razorfish

Xyrichthys splendens (now Green Razorfish, *Xyrichtys splendens*) (top), *Johnius crouvina* (now *Plagioscion crouvina*) (bottom). Hand coloured lithograph, pl. 5 from F. L. Castelnau's *Zoologie. Poissons* (Vol. 7, Part 5 of his *Expédition dans les Parties Centrales de l'Amérique du Sud*), 1850–59. Size of plate 11½″ × 8½″.

In the 1840s, Count Francis L. de Laporte de Castelnau conducted a major French expedition to study the natural history of the central regions of South America, and he edited a multi-volume account of it in the 1850s. Most of the specialist reports describing the animals and plants collected during the expedition were written by others but he was responsible for an attractively illustrated report on the fish. Looking at illustrations such as this it is easy to forget how difficult it must have been to collect, preserve and sketch fish and other natural objects under the trying conditions of the tropics.

The green razorfish, a five-inch long member of the wrasse family found from southern Florida southwards to Brazil, lives over patches of sand, as do the 20 or more other species of razorfish. If threatened it dives head first into the sand. It will also hide in beds of seagrass and can alter its colour to a barred pattern which makes it difficult for a predator to find it amongst the vegetation.

Castelnau's *Johnius crouvina* is a species of 'croaker' or 'drum', so called because of the drumming sound produced by the swim bladder, and is a coastal or estuarine fish.

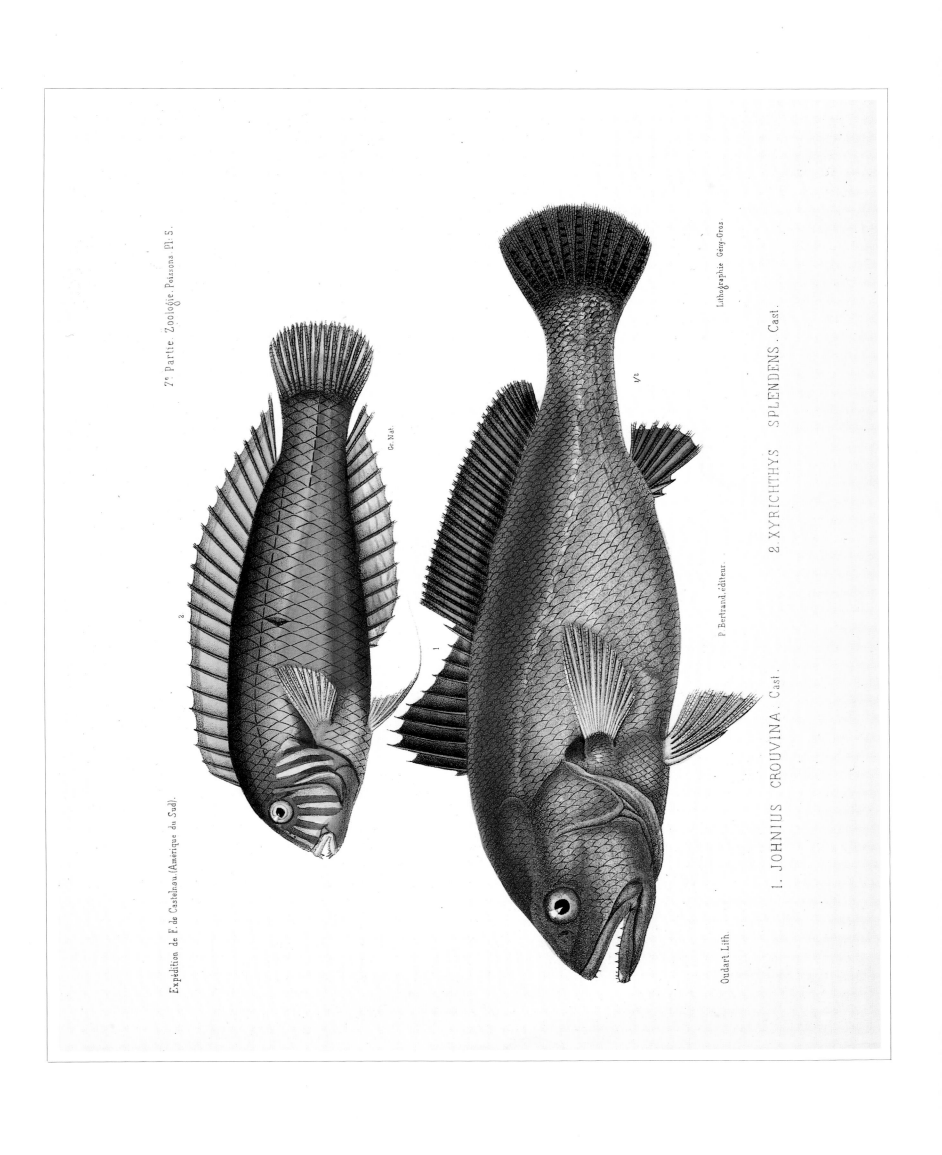

7e Partie Zoologie. Poissons. Pl. 5.

Gr. Nat.

Expédition de F. de Castelnau (Amérique du Sud).

Lithographie Geny-Gros.

P. Bertrand, éditeur.

Oudart Lith.

1. JOHNIUS CROUVINA. Cast. 2. XYRICHTHYS SPLENDENS. Cast.

Three Freshwater Stingrays

THREE STINGRAYS, *Taenura dumerilii* (now *Potamotrygon dumerili*), *Taenura mulleri* (now *Potamotrygon motoro*), *Taenura henlei* (now *Potamotrygon henlei*). Hand coloured lithograph by P. L. Oudart, pl. 48 from F. L. Castelnau's *Zoologie, Poissons* (Vol. 7, Part 5 of his *Expédition dans les Parties Centrales de l'Amérique du Sud*), 1850–59. Size of plate 11½″ × 8½″.

Shown here are three very closely related species of stringray, each of which inhabits lakes and slow-flowing rivers of South America. Curiously, the artist chose to show the specimens overlapping each other in such a way that the distinguishing features of at least one are almost totally obscured. The result may be artistically pleasing and economical but it cannot be considered a sound example of scientific illustration. Indeed, this picture may have contributed to a long-held opinion among fish specialists that the three species were identical, an opinion not revised until very recently. The artist/lithographer was Paul-Louis Oudart who was trained in the French miniaturist tradition early in the nineteenth century, a tradition which imbued scientific illustration with a marked decorative quality and allowed Pierre-Joseph Redouté and other fine natural history artists to flourish. The decorative content of this illustration may owe something to that tradition.

Most stingrays are marine creatures but some species, such as these, live only in fresh water, lurking in the shallows and often partially covered by mud. At the beginning of the nineteenth century the great German explorer Alexander von Humboldt found them a daily hazard during his epic journey along the River Orinoco. Even today the native Indians fear them because of their poisonous spines which may inflict painful, occasionally fatal wounds.

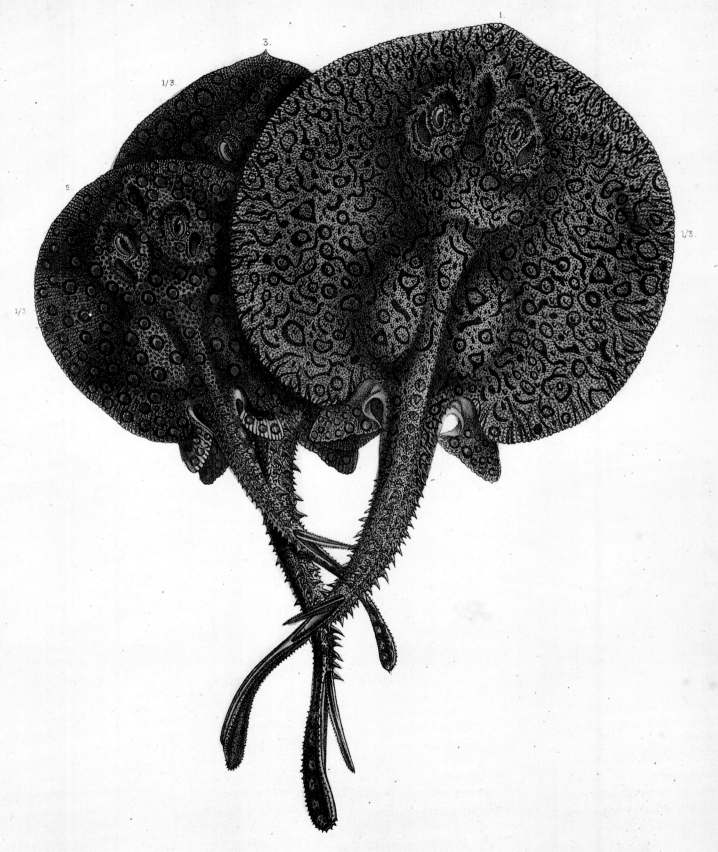

Oudart. Lith. P. Bertrand, éditeur. Lithographie Gény-Gros, Paris.

1. TÆNURA DUMERILII. Cast. 2. TÆNURA MULLERI. Cast. 3. TÆNURA HENLEI. Cast.

Great White Shark

WHITE SHARK, *Carcharias carcharias* (now also Great White Shark, White Pointer, Man-eater, White Death, *Carcharodon carcharias*). Colour printed wood engraving by Benjamin Fawcett, pl. 5 from Vol. 1 of J. Couch's *A History of the Fishes of the British Islands*, 1862–65. Size of plate 10″ × 6¼″.

The star of Peter Benchley's book and Steven Spielberg's film *Jaws* finds a place in Couch's book on British fish on the slightest of evidence, a vague report that 'several others have been seen in Mount's Bay, Cornwall . . . and one, which was seen by a gentleman who had often observed the White Shark in the West Indies, and was pronounced by him to be of the same species.' His pronouncement was probably inaccurate because there have been no reliable records of it appearing in British waters since.

Despite the hysteria engendered by *Jaws*, however, shark attacks are rare. Indeed, perhaps no more than 50 people world wide are killed by sharks of all kinds in a year. As we kill about five million sharks annually who are the real aggressors?

Six-gilled Shark

SIX-GILLED SHARK, *Notidanus griseus* (now *Hexanchus griseus*). Colour printed wood engraving by Benjamin Fawcett, pl. 4 from Vol. 1 of J. Couch's *A History of the Fishes of the British Islands*, 1862–65. Size of plate 10″ × 6¼″.

Jonathan Couch's four-volume book about fish recorded from British waters is a well-known popular study of the subject, the many plates illustrating it often being seen for sale in print shops. Occasionally, as here, the subject is shown against a delicately engraved scenic background which enhances its appeal.

As its common name suggests, this shark has six gill slits on either side of the head, most other sharks having only five. It attains a length of about fifteen feet and feeds mostly on fish and crustaceans, but it has been known to include seals in its diet. Generally regarded as a deep-water shark it strays occasionally into shallower, inshore waters.

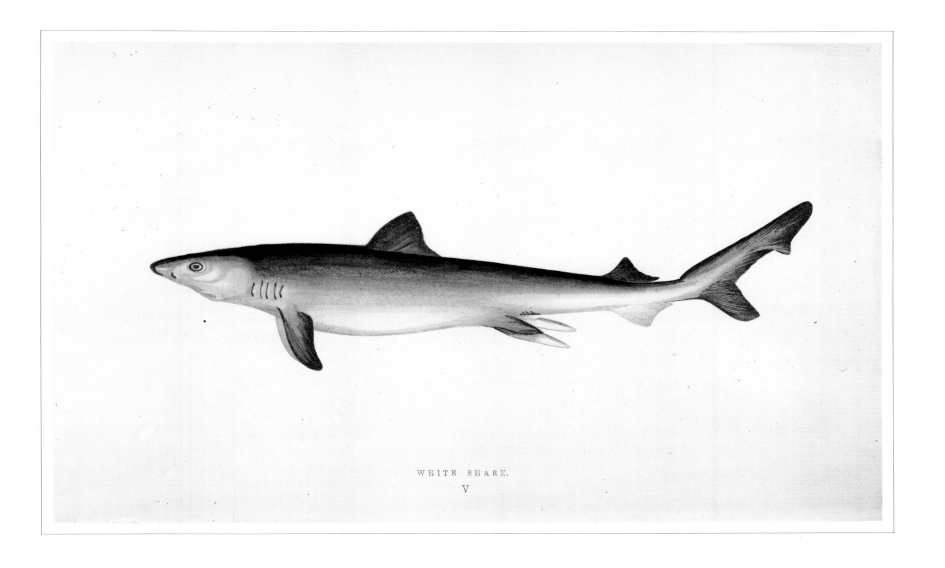

WHITE SHARK.

V

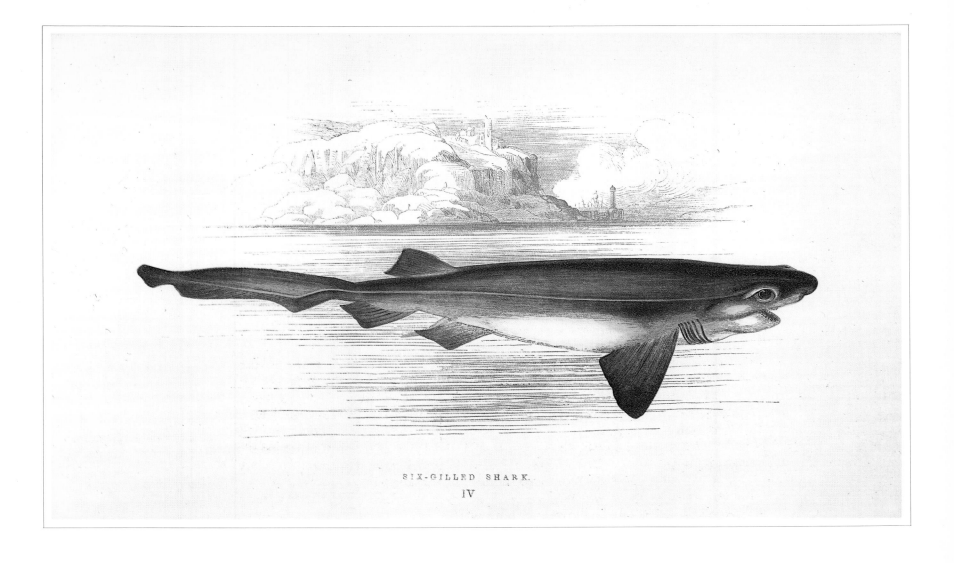

SIX-GILLED SHARK.

IV

Blue Shark

BLUE SHARK, *Carcharias glaucus* (now *Prionace glauca*). Colour printed wood engraving by Benjamin Fawcett, pl. 6 from Vol. 1 of J. Couch's *A History of the Fishes of the British Islands*, 1862–65. Size of plate 10″ × 6¼″.

Described by Couch as 'a restless and wandering fish' the blue shark usually cruises near the surface of warm-temperate, subtropical and tropical oceans but may be seen in the cooler waters around the British Isles, especially during the summer. A streamlined shark, it hunts mainly fish and squid although it has attacked people swimming in tropical waters.

The blue shark grows to a length of about twelve feet or more and has long, sickle-shaped pectoral fins, as shown in this picture. It is white underneath and the back is a bright metallic blue, not the subdued blue shown here.

Bramble Shark

SPINOUS SHARK, *Echinorhinus spinosus* (now Spiny Shark, Bramble Shark, *Echinorhinus brucus*). Colour printed wood engraving by Benjamin Fawcett, pl. 12 from Vol. 1 of J. Couch's *A History of the Fishes of the British Islands*, 1862–65. Size of plate 10″ × 6¼″.

All the popular names of this shark indicate the presence on its skin of numerous, sharp, curved spines, each spine being mounted on a button-like pad. It occurs in the Mediterranean and the eastern Atlantic from southern Britain to West Africa and is a bottom dweller, its food comprising other sharks, fish and crustaceans. As with so many pictures of fish dating from the nineteenth century and earlier the artist has shown his subject as though beached in a most improbable manner. Couch knew of very few records of this shark from British waters and this may account for some inaccuracies in his picture, such as the exaggerated thickness of the rear part of the shark's body and its unnaturally blunt head.

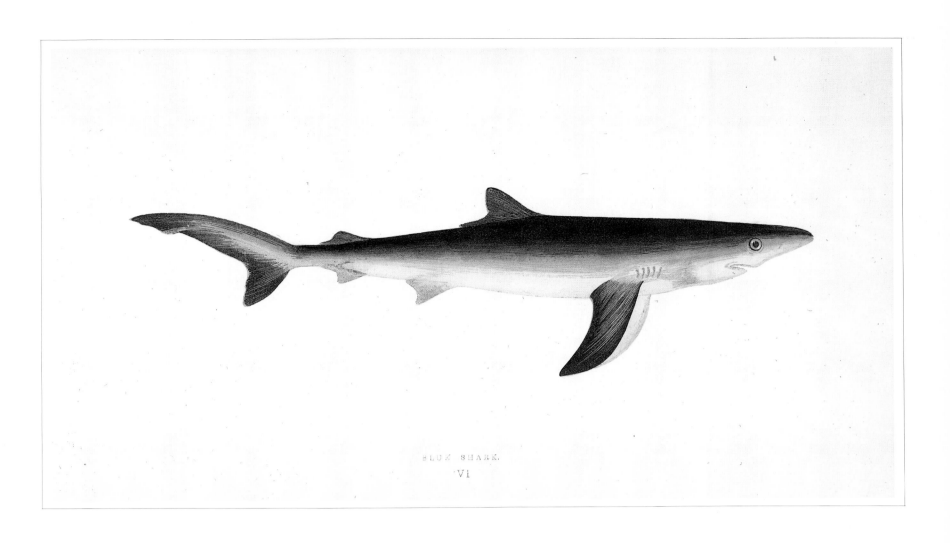

BLUE SHARK.

VI

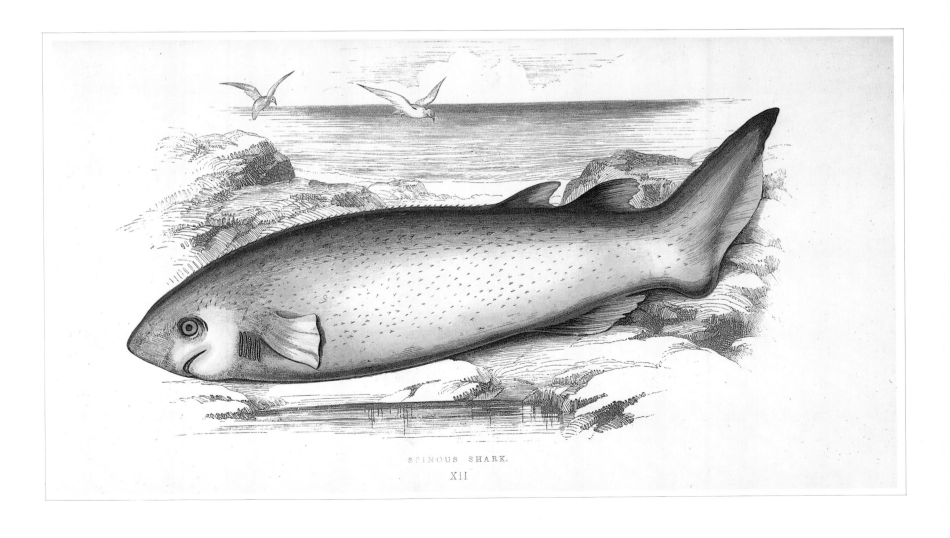

SPINOUS SHARK.

XII

Three Wrasses

Pseudocoris heteropterus (top) and two other Wrasses. Chromolithograph, pl. 19 from Vol. 1 of P. Bleeker's *Atlas Ichthyologique des Indes Orientales Néerlandaises*, 1862–78. Size of plate 18″ × 11¾″.

Pieter Bleeker was a Dutchman whose abiding passion was the study of fish, especially those of the Indonesian archipelago. He began publishing articles about them as a young man and in 1855, at the age of 36, collected fish and other natural objects when attached as a surgeon to an expedition to the Molucca Islands. He went on to become one of the foremost authorities on fish of all time, his great *Atlas Ichthyologique des Indes Orientales Néerlandaises*, in nine folio volumes, being his lasting memorial. It would have been possible to have filled our own book with reproductions of his beautiful illustrations, among the best ever published before the days of colour photography.

Pseudocoris heteropterus was only one of many wrasses he would have seen in the warm waters of Indonesia. He would also have seen several species of *Coris*, the members of this genus differing from those of *Pseudocoris* by not having the canine teeth of the upper jaw curved outwards; even such apparently insignificant features as the configuration of teeth may be important to students of fish classification.

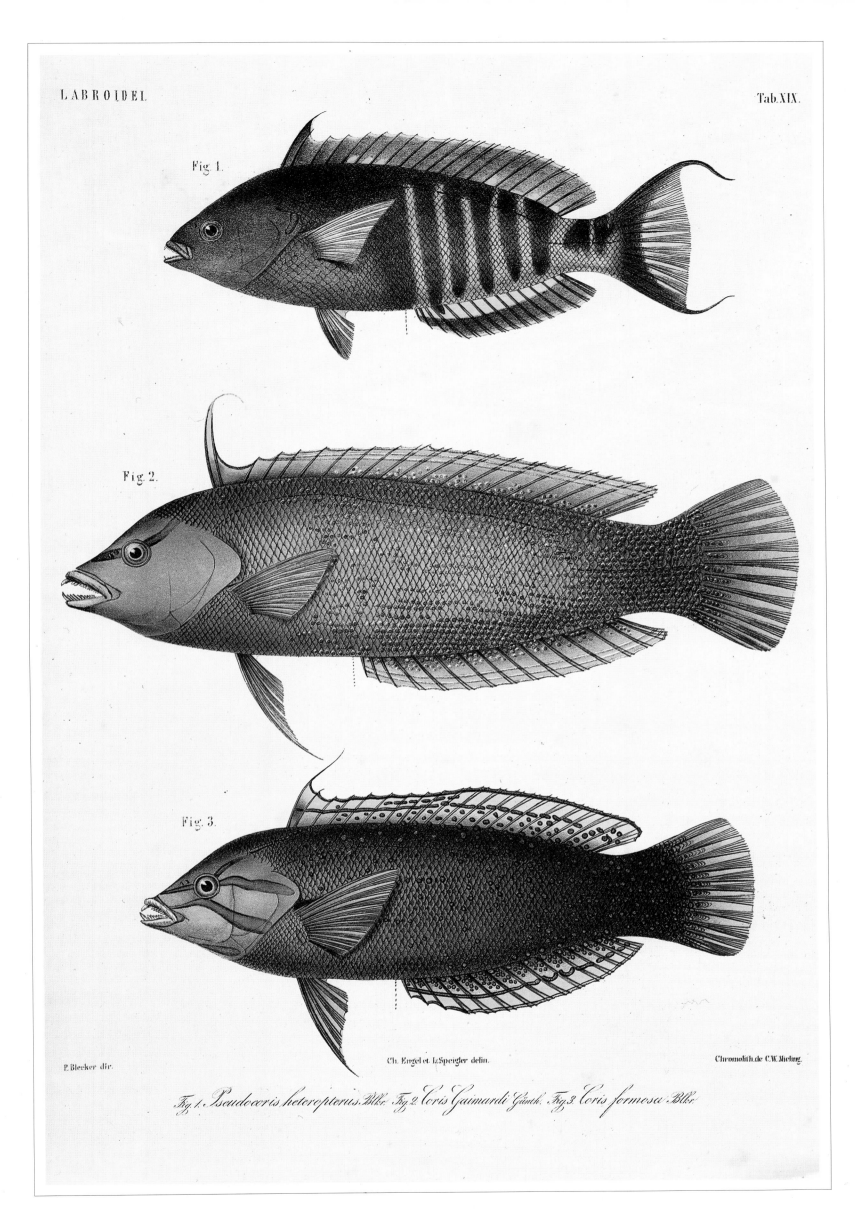

Fig. 1.

Fig. 2.

Fig. 3.

P. Bleeker dir.

Ch. Engel et L. Speigler delin.

Chromolith. de C.W. Mieling.

Fig. 1. Pseudocoris heteropterus. Blkr. Fig. 2. Coris Gaimardi. Günth. Fig. 3. Coris formosa. Blkr.

Three Pufferfish and a Porcupinefish

PORCUPINEFISH, family Diodontidae (third from top) and three Pufferfish family Tetraodontidae. Chromolithograph after original drawings by L. Speigler, pl. 206 from Vol. 5 of P. Bleeker's *Atlas Ichthyologique des Indes Orientales Néerlandaises*, 1862–78. Size of plate 18″ × 11¾″.

Pieter Bleeker's *Atlas Ichthyologique* may be considered one of the two most impressive books on fish ever published (the other being Elieser Bloch's *Ichtyologie*). His book is a treasury of beautiful and accurate figures of fish, mostly those inhabiting the warm tropical waters of Indonesia, and is still an important reference for students of fish.

All the fish shown here, if threatened, inflate the body with water, blowing themselves up into a prickly ball – an intimidating mouthful for would-be predators. Many species have a second line of defence: they are very poisonous. Puffers contain an alkaloid in the skin, liver and ovaries so potent that a rotting pufferfish has been reported to kill off flies by the hundreds. Despite this poisonous quality specialist restaurants in Japan serve the flesh of puffers as a gourmet delicacy, known as *Fugu*. Only specially trained and licensed cooks may prepare it as great care is required to make the fish safe for human consumption. Even so, several deaths from *Fugu* are recorded annually.

[88]

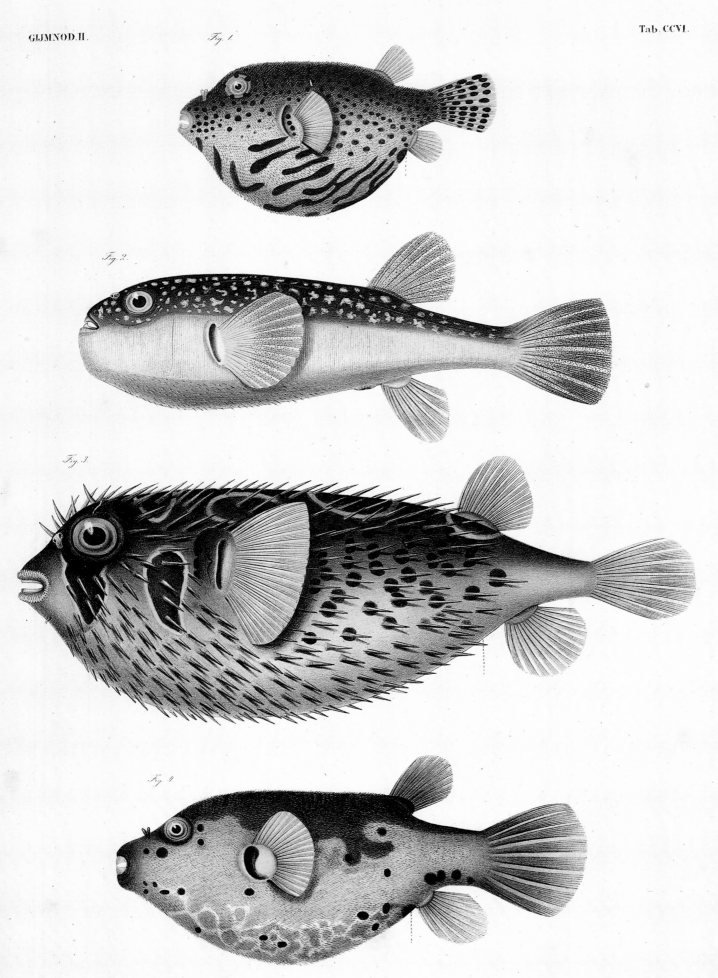

P. Bleeker dir. L. Speigler del. Chromolith. de C.W. Mieling.

Fig. 1 Crayracion lineatus Blk. Fig. 2. Tetraodon Honckenü Bl. Fig 3. Paradiodon novemmaculatus Blk.
Fig. 4 Crayracion nigropunctatus Blk.

Brindled Grouper

Serranus lanceolatus (now Brindled Grouper or Jewfish, *Epinephelus lanceolatus*). Hand coloured lithograph, pl. 1 from Francis Day's *The Fishes of Malabar*, 1865. Size of plate 9¾″ × 8¼″.

The fish shown here are the juvenile (upper) and adult (lower) forms of the largest of the nearly 400 species of sea bass belonging to the family Serranidae. Before it exceeds a length of four inches the brindled grouper displays a striking brindled pattern of yellow and black, but this becomes a more subdued mottling of grey, black and yellow as it continues growing. Large individuals attain a length of about nine feet and are generally uniformly greyish.

It occurs down to about 300 feet and often resorts to caves in coral reefs. Widespread in the Indian Ocean and the western Pacific, this large predator has become scarce, probably through overfishing. In Natal fishermen are forbidden to keep specimens below a minimum of a foot in length and spear-fishing for them has been banned.

PLATE I.

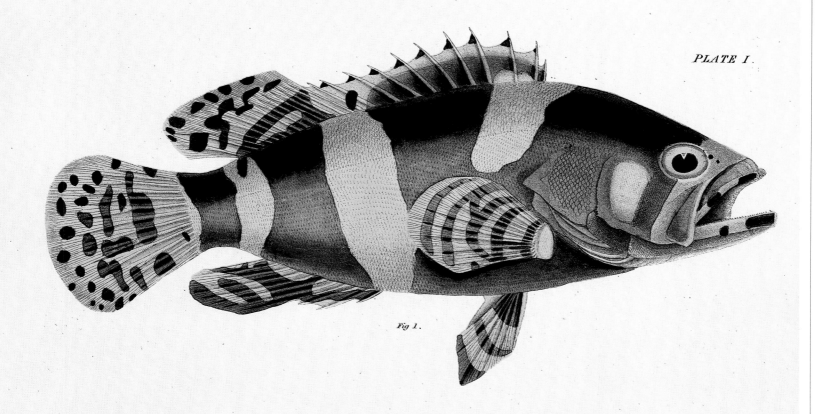

Fig 1.

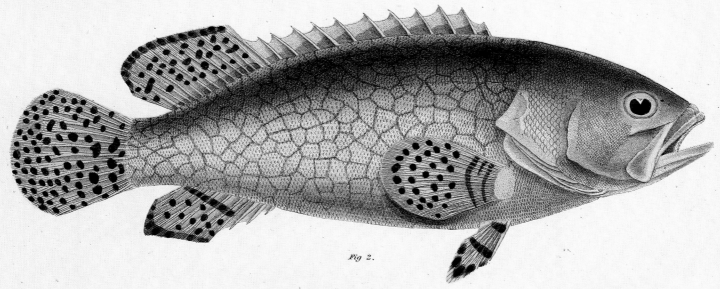

Fig 2.

F. Day, del. et sculp.

1. SERRANUS LANCEOLATUS. (Young.)　2. SERRANUS LANCEOLATUS. (Adult.)

Bullethead Parrotfish

Pseudoscarus troscheli, (now Bullethead or Daisy Parrotfish, *Scarus sordidus*). Hand coloured lithograph by G. H. Ford, pl. 14 from R. L. Playfair and A. C. Guenther's *The Fishes of Zanzibar*, 1866. Size of plate 13″ × 9″.

From the number of times parrotfish appear in this book it seems they must be abundant, easy to capture, or both. Abundant they certainly are, any coral reef being likely to have several species in attendance; and some of them are easy to capture, particularly at night. At the day's end many species retire to a crevice and secrete around themselves a mucous sheath, breaking out of it at daybreak to start hunting for food again. When in their cocoon they may be picked out of the water easily by hand as long as they are treated gently.

A common species throughout the Indo-Pacific region, the bullethead parrotfish grows to a length of about fifteen inches. Like most parrotfish it is brightly coloured but, as this illustration shows, it may assume different colours. To be more precise, the adult fish has two colour phases. In the first the body is brown with dull yellow edges to its scales. In the second the body is green with a pale green line traversing the length of the dorsal fin, as our central figure shows. The first colour phase is displayed by individuals of either sex. Only males display the second colour phase.

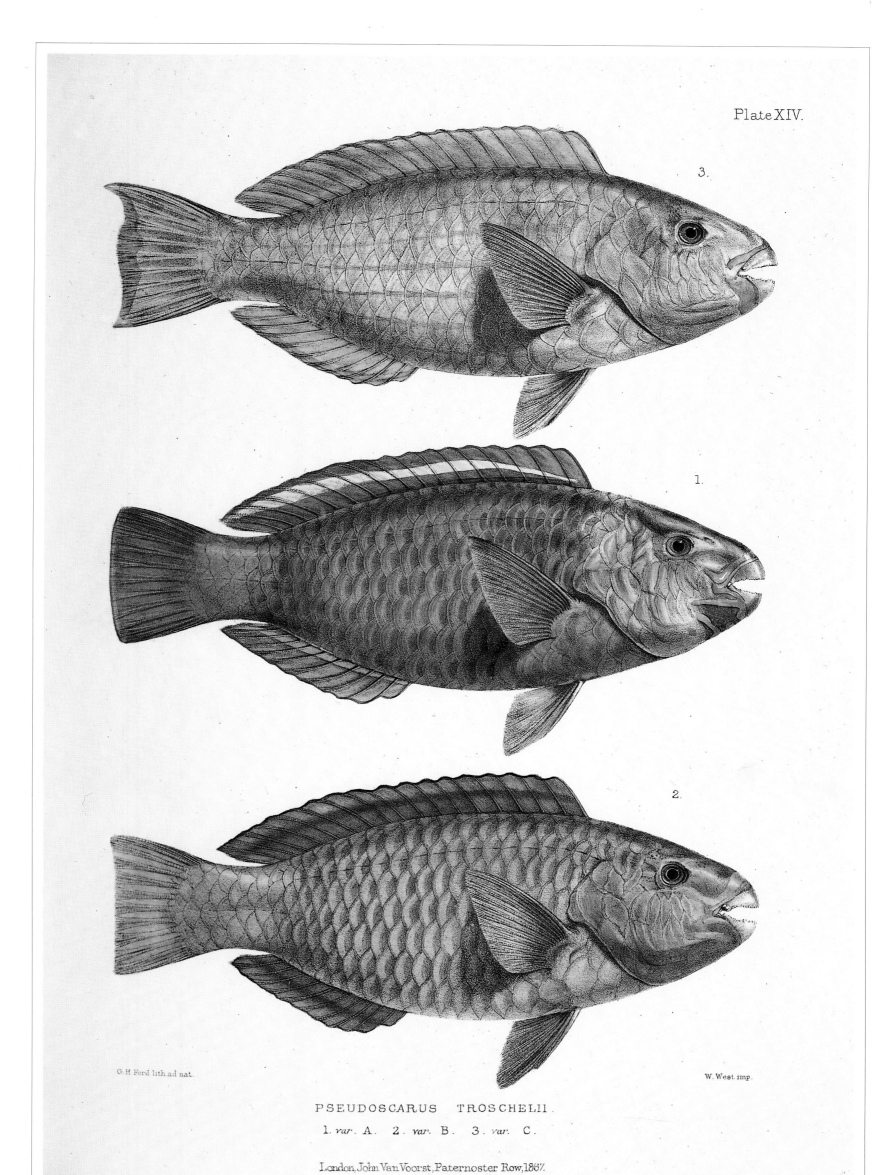

Plate XIV.

G.H.Ford lith.ad nat.

W.West.imp.

PSEUDOSCARUS TROSCHELII.

1. *var.* A. 2. *var.* B. 3. *var.* C.

London, John Van Voorst, Paternoster Row, 1867.

Emperor Angelfish

Holocanthus nicobariensis (top), *Holocanthus imperator* (bottom) (both now Emperor Angelfish, *Pomacanthus imperator*). Hand coloured lithograph, pl. 41 from A. C. Guenther's *A. Garrett's Fische der Sudsee*, 1873–1910. Size of plate 13″ × 9½″.

Neither Andrew Garrett, who painted the original watercolours, nor Albert C. Guenther, who edited the book in which they were published, was aware that these two drawings represent the same species. In all angelfish the juvenile has a colour pattern different from that of the adult, but not until 1933 was it realised that the emperor angelfish spent the early part of its life masquerading as an apparently different species. This arrangement has survival value for the fish; the adult is more inclined to accept what it may see as a different and non-competing species around its territory than it would one of its own kind. The juxtaposition of the two forms of the species on the same page was probably fortuitous but may now be seen as prophetic.

The foot-long emperor angelfish, a great attraction in any aquarium, ranges from the Red Sea to Polynesia. It occurs, either singly or in pairs, on outer reefs of living coral down to about 75 feet and when disturbed will dart into a nearby cave or under a ledge. This highly prized fish is able to make curious clicking noises which are audible underwater.

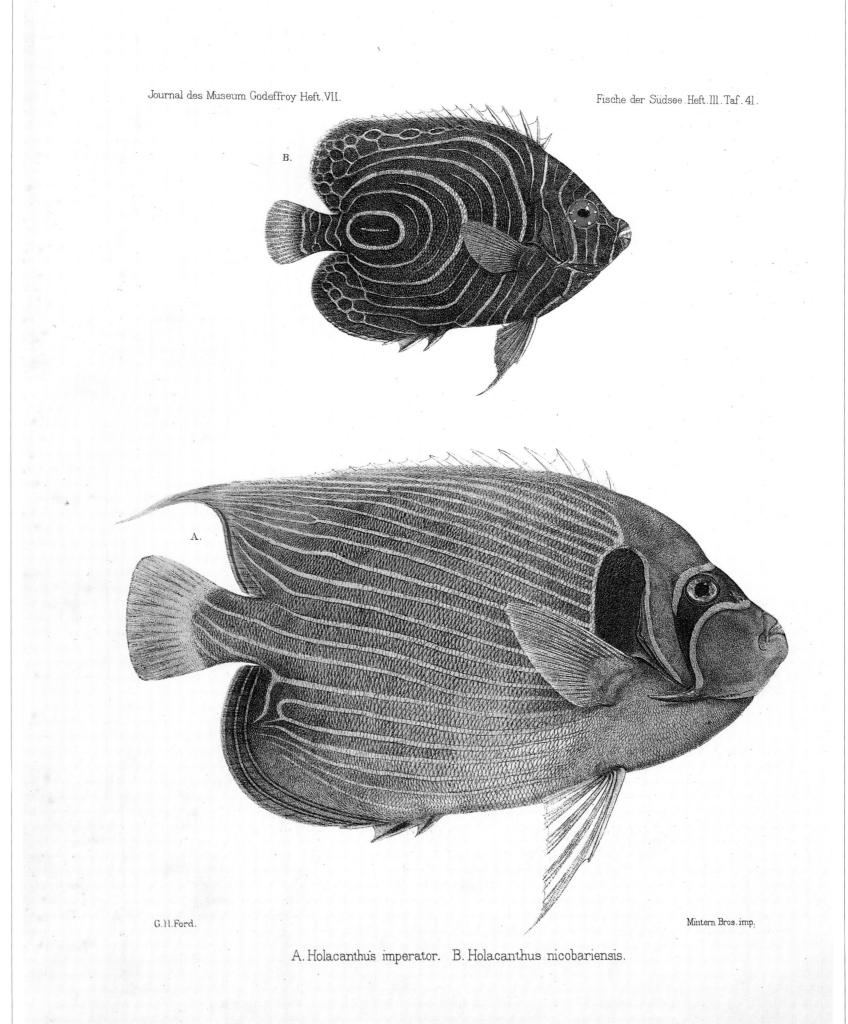

G.ll.Ford. Mintern Bros.imp.

A. Holacanthus imperator. B. Holacanthus nicobariensis.

Vermilion Seabass

Serranus miniatus (now Vermilion Seabass or Coral Rockcod, *Cephalophis miniata*). Hand coloured lithograph, pl. 5 from A. C. Guenther's *A. Garrett's Fische der Sudsee*, 1873–1910. Size of plate 13″ × 9½″.

With a maximum length of about sixteen inches this is one of the smaller members of the Serranidae, a family including groupers and basses, some of which may grow up to nine feet in length. A widespread Indo-Pacific fish, it is commonly found in shallow waters around coral reefs where it seeks the cover of caves, ledges and crevices. It feeds mainly upon crabs, shrimps and smaller fish.

One of several blue-spotted bass, its body is a deeper reddish-orange colour that is suggested by this lithograph. A fish rapidly loses its colours when removed from the water. In the days before colour photography it was very difficult for an artist to make even a rapid coloured sketch before the fish had changed colour. This may explain the muted colouring on the lithograph which would have been based on a mid-nineteenth-century drawing by Andrew Garrett, an American naturalist who spent most of his working life in Polynesia. Besides collecting and studying fish, shells and other natural objects, Garrett made nearly 500 beautiful watercolour drawings of fish which were edited by Albert C. Guenther of the British Museum. Undoubtedly the natural colouring of some of the fish would have changed before he had begun or before he had finished his drawings of them. Apart from the muted colouring, however, this is an excellent portrait of a vermilion seabass.

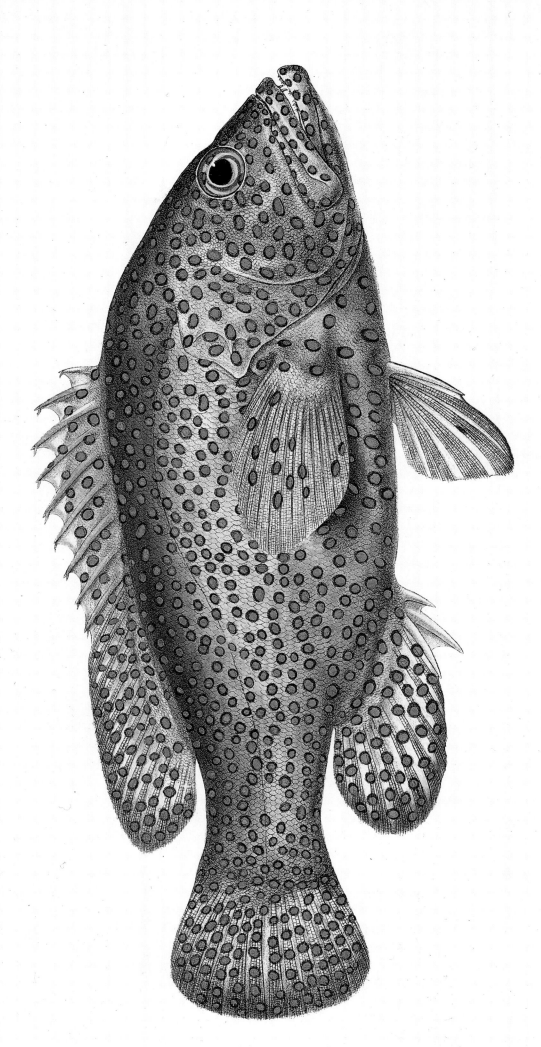

Serranus miniatus.

Dusky Parrotfish

Pseudoscarus nuchipunctatus, (now Dusky Parrotfish, *Scarus niger*). Hand coloured lithograph, pl. 157 from A. C. Guenther's *Garrett's Fische der Sudsee*, 1873–1910. Size of plate 13″ × 9½″.

From its colouring the fish shown here is clearly a male dusky parrotfish, but it would have begun life as a female. This species, like many other reef-dwelling fish, changes sex. With the sex change comes a change in colour. In life the fish would have been more brightly coloured than it is represented here: very probably, this specimen would have been dead for some time before the artist, Andrew Garrett, recorded its likeness in watercolours. Even so, the light spot just behind the gill openings, so distinctive of this species, is clearly shown.

This is a widespread, reef-dwelling species in the Indo-Pacific region and reaches a length of about sixteen inches. Like other parrotfish it feeds mainly on algae which it scrapes off the reef with its beak-like teeth. Inevitably, along with the algae, it scrapes away coral fragments which pass through its digestive system. The effect of this behaviour by countless parrotfishes over long periods of time is the formation of much of the fine coral sand which is such an attractive feature of many tropical beaches.

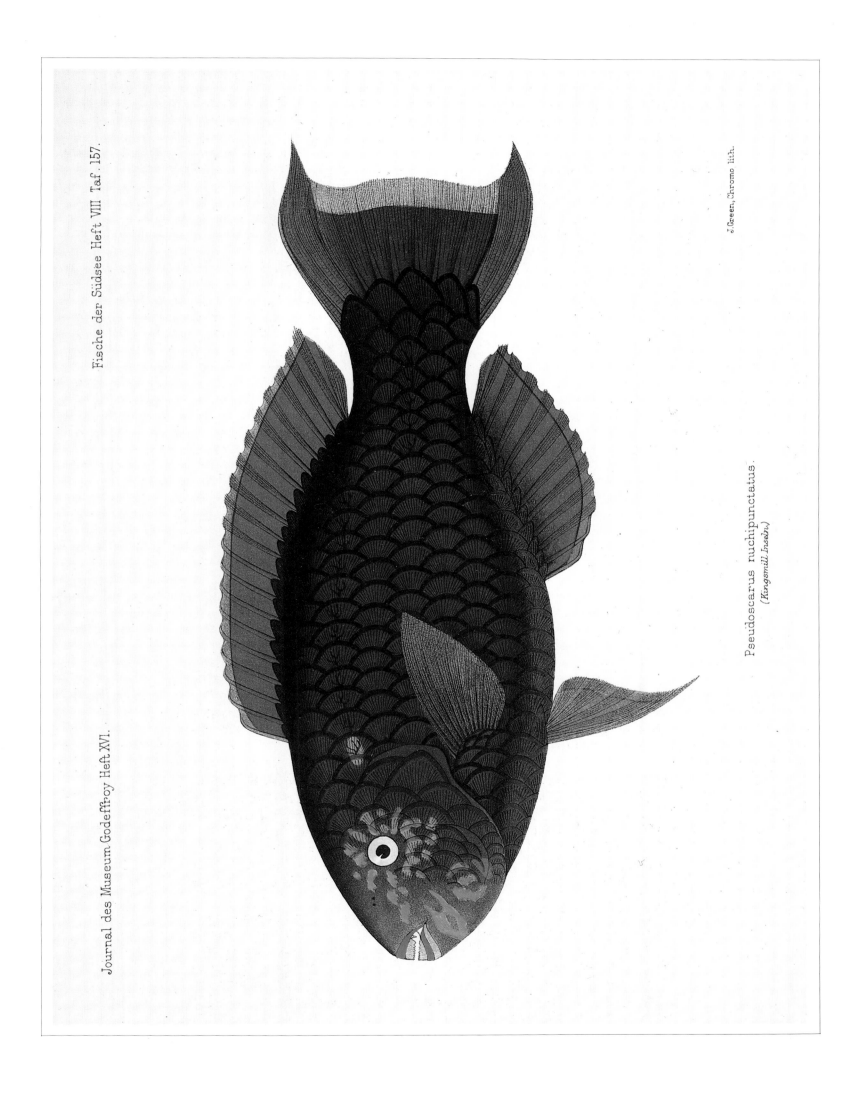

Journal des Museum Godeffroy Heft XVI.

Fische der Südsee Heft VIII Taf. 157.

J.Green, Chromo lith.

Pseudoscarus ruchipunctatus.
(*Kingsmill Inseln.*)

Leopard Moray Eel

Muraena undulata (now Leopard Moray Eel, *Gymnothorax undulatus*). Hand coloured lithograph, pl. 164 from A. C. Guenther's *A. Garrett's Fische der Sudsee*, 1873–1910. Size of plate 13″ × 9½″.

Here we see one of the many colour forms of the common and widely feared leopard moray. Widespread over most of the Indo-Pacific region it reaches a length of about five feet and, as its scientific name suggests, is patterned with undulating bands, these generally being broken to give a mottled effect. These markings break up the body's outline making it inconspicuous in its coral reef environment.

The leopard moray's jaws are equipped with large, sharp, backwardly pointing teeth which may deliver a nasty bite to a human hand or foot straying inadvertently into a crevice which the creature regards as its own territory. Because such bites may cause serious wounds which are prone to infection, fishermen in tropical waters are wary of large specimens of this and other related species. Their evil reputation for vicious and unprovoked attacks, however, seems to be unsubstantiated and undeserved. Undeniably, with their formidable teeth and unblinking eyes, they are somewhat intimidating and there is a prevalent notion that they have a mean streak. Anyway, human beings get their own back by eating them. A Mediterranean species was so highly esteemed by the Romans that they kept them in specially constructed reservoirs – and reputedly fattened them on the corpses of dead slaves!

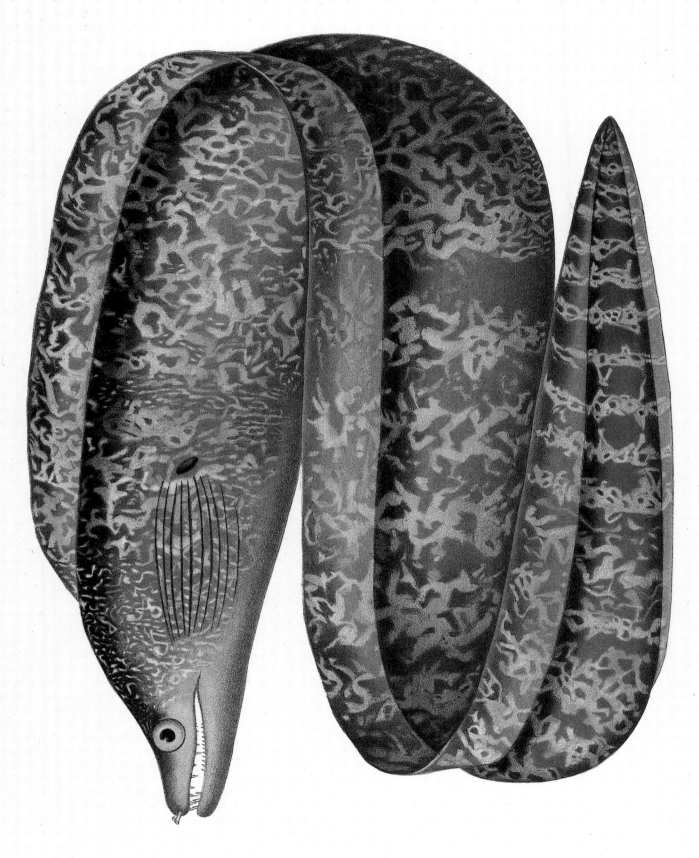

Muraena undulata, var.
(Gesellschafts-Inseln.)

Werner & Winter, Frankfurt ⁹M.

Hamburg, L. Friederichsen & Cⁿ

Rippled Triggerfish

Balistes fuscus, (now Rippled Triggerfish, *Pseudobalistes fuscus*). Hand coloured lithograph, pl. 168 from Albert C. Guenther's *A. Garrett's Fische der Sudsee,* 1873–1910. Size of plate 13″ × 9½″.

Many species of triggerfish live around coral reefs and, like other reef fishes, are spectacularly marked. With their powerful jaws they break open and eat crabs, sea urchins and shelled molluscs. The rippled triggerfish is found throughout the Indo-Pacific region.

But why are they called triggerfish? There are three spines associated with the dorsal fin: the first and largest is stout and is hollowed out behind to receive a bony knob at the base of the much smaller spine behind it; the larger spine remains erect as long as the smaller spine is locked into it. By depressing the smaller spine in the same way that the trigger of a gun is depressed, the large spine may be released. The value of this curious arrangement may be seen when a triggerfish darts for cover into a crevice; once inside the crevice the locking device is activated and the fish is wedged immovably therein. A bright livery frequently warns potential predators that a species is unpalatable and triggerfish often contain poisonous substances.

Werner & Winter, Frankfurt °/M.

Balistes fuscus
(Kingsmill-Inseln)

Journal des Museum Godeffroy Heft XVII.

Hamburg. L. Friederichsen & Cº.

Atlantic Spanish Mackerel

SPANISH MACKEREL, *Cybium maculatum* (now Atlantic Spanish Mackerel, *Scomberomorus maculatus*). Chromolithograph after a painting by G. A. Kilbourne, pl. 3 from S. A. Kilbourne and G. B. Goode's *Game Fishes of the United States*, 1878–80. Size of plate 20¾″ × 14″.

This spirited picture comes from one of the few nineteenth-century books about fish which attempts to show them as living creatures swimming in their natural environment. The Spanish mackerels, of which there are eighteen species, are predatory fish with streamlined bodies and are found in most tropical and subtropical seas. The Atlantic Spanish mackerel reaches a length of 36 inches and may weigh up to ten pounds. In winter it is to be found in the waters of Florida and the Gulf of Mexico but at other times may be found as far north as Cape Cod.

The Atlantic Spanish mackerels of the genus *Scomberomorus* should not be confused with the smaller *Scomber japonicus*, the Spanish mackerel of the eastern Atlantic and the Mediterranean. But how did these large fish acquire the same name as the smaller fish? The authors of *Game Fishes of the United States* offer a plausible explanation. 'English colonists, the world over,' they say, 'have always given to the native animals of the new country the names of those with which they were familiar in their ancestral home. The Spanish mackerel of England was a fish with spotted sides. The people of New England found a spotted mackerel and called it by the old, familiar name; those of the Middle States did likewise with a different kind of spotted mackerel.' They also suggest that the name 'Spanish mackerel' originated from a statement in a sixteenth-century French treatise alleging that the fish in question was particularly abundant in Spanish waters.

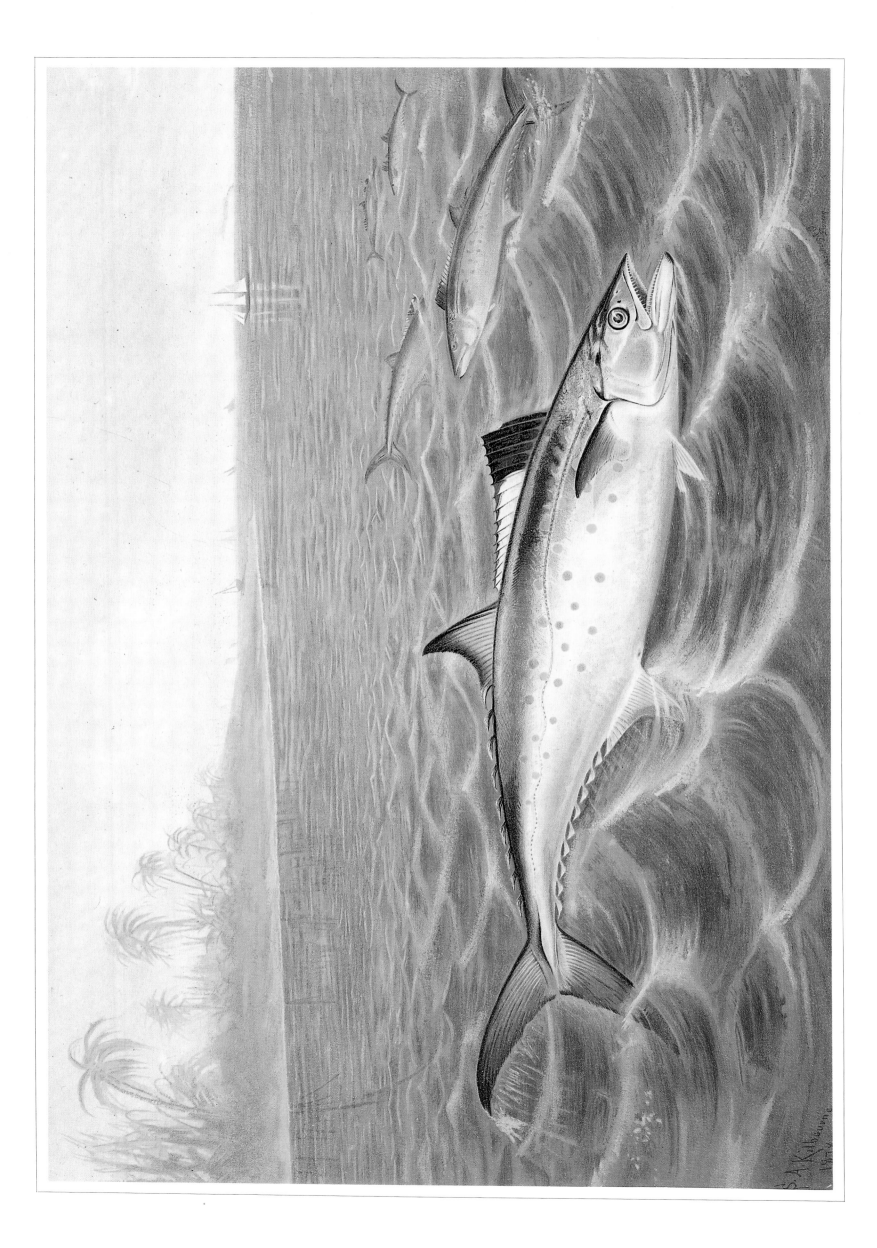

Red Snapper

RED SNAPPER, *Lutjanus blackfordii* (now *Lutjanus campechanus*). Chromolithograph after a painting by S. A. Kilbourne, pl. 6 from S. A. Kilbourne and G. B. Goode's *Game Fishes of the United States*, 1878–80. Size of plate 20¾″ × 14″.

About 150 or more kinds of snappers, members of the family Lutjanidae, are known from warm seas world-wide. All are carnivorous and feed mostly on crustaceans at night. By day they form large schools near the shelter of reefs. Many of them are commercially important, few more so than the red snapper. This tasty fish reaches a length of about two and a half feet and a weight of about 20 pounds or more. Its headquarters is the Gulf of Mexico and southern Florida although in summer it may roam northwards as far as the Massachusetts coast.

The authors of the book from which the picture has been taken comment on the popularity of red snapper fishing as it was in the 1870s. 'A trip to the snapper banks,' they tell us, 'is a favourite summer recreation for the gentlemen of Jacksonville. A tug is chartered for the day, and usually returns to the city with flags flying, whistles triumphantly sounding, and gorgeous festoons of red fish hanging over the bows.' A favourite fish with sea anglers, the red snapper has continued to offer sport to many in the twentieth century.

Although Goode and Kilbourne appear as joint authors of *Game Fishes of the United States*, all the plates were from original paintings by Kilbourne and the text was entirely the work of George Brown Goode, the great authority on North American fishes.

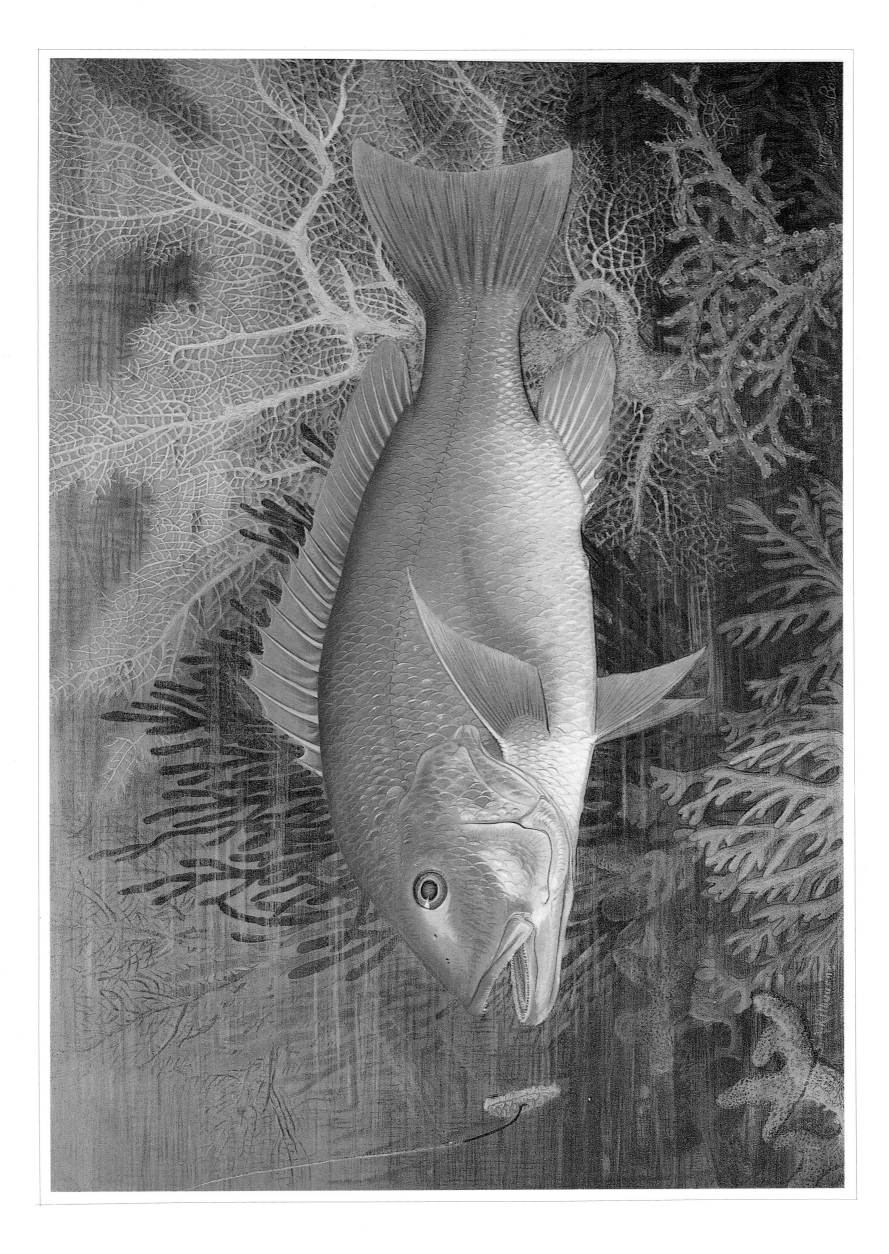

Arctic Grayling

GRAYLING, *Thymallus tricolor* (now Arctic Grayling, *Thymallus arcticus*). Chromolithograph after a painting by S. A. Kilbourne, pl. 18 from S. A. Kilbourne and G. B. Goode's *Game Fishes of the United States*, 1878–80. Size of plate 20¾″ × 14″.

The fish shown here is not the grayling of northern Europe but the similar species found in North America and eastern Asia, the Arctic grayling. Its chief characteristic is its large dorsal fin, which is brightly coloured with red spots and bands of green and blue. Attaining a length of about fifteen inches it is confined to cool, clear waters of rivers or lakes and occurs naturally, in North America, from Hudson Bay westwards to Alaska. So highly is it regarded as a sport fish that it has been introduced into suitable highland habitats in the United States and now occurs as far south as California, Arizona and Nevada. Its range in Asia extends into Russia and southwards into China.

The authors of the large folio book from which this picture has been taken say that the Michigan town of Grayling, formerly called Crawford, was the headquarters of grayling fishermen. They also quote someone who had become a great admirer of this fish through his angling activities. 'There is no species sought for by anglers that surpasses the grayling in beauty. They are more elegantly formed and more graceful than the trout, and their great dorsal fin is a superb mark of loveliness. When the well-lids were lifted, and the sun's rays admitted, lighting up the delicate olive-brown tints of the back and sides, the bluish-white of the abdomen, and the mingling of tints of rose, pale blue and purplish pink on the fins, they displayed a combination of colors equaled by no fish outside of the tropics.'

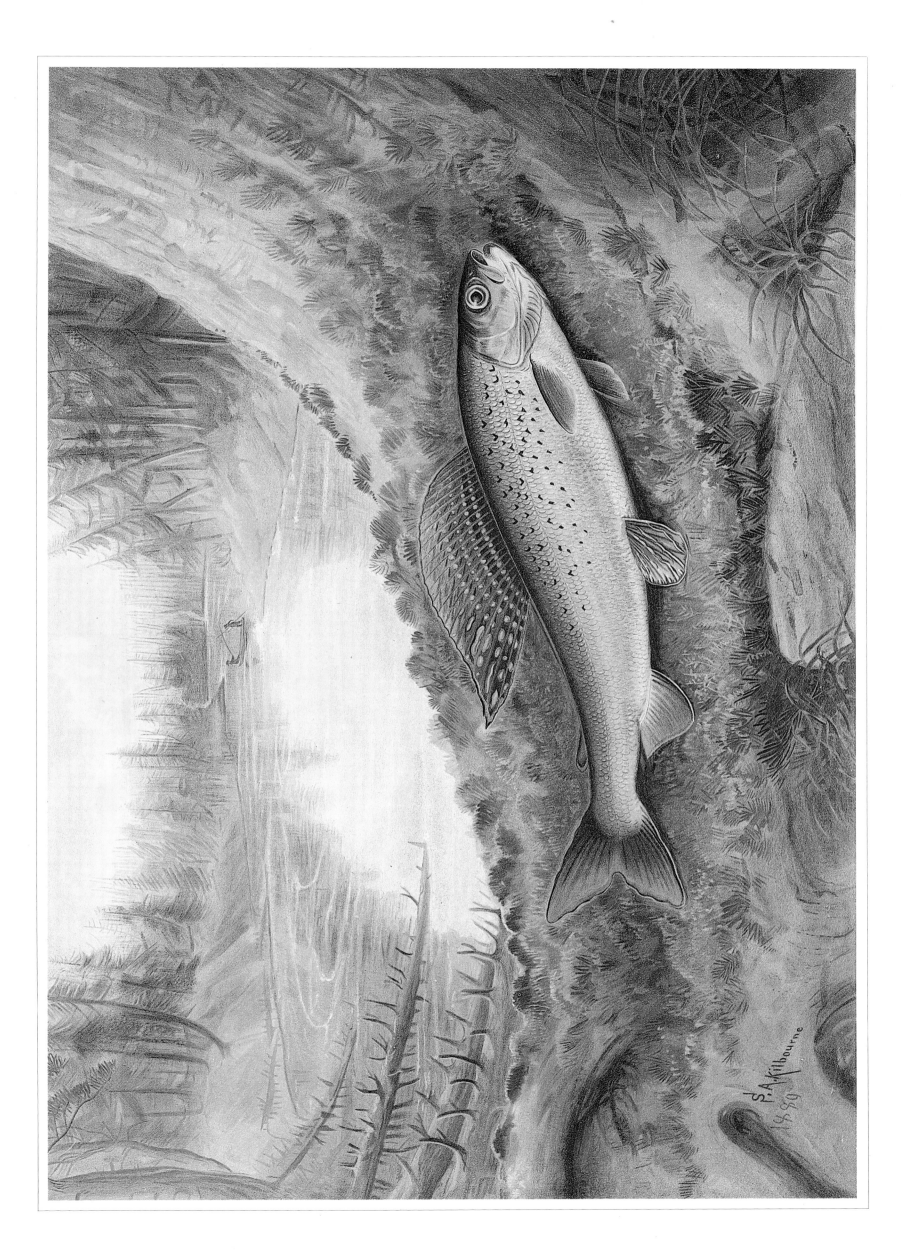

Goldfish

GOLDEN CARP, *Carassius auratus* (now Goldfish). Colour-printed wood engraving by Benjamin Fawcett after an original drawing by A. F. Lydon, pl. 6 from W. Houghton's *British Fresh-water Fishes*, 1879. Size of plate 14″ × 10½″.

The larger, bronze-coloured specimen in this picture represents the 'wild' form, the two upper specimens the ornamental or 'pet' form of the familiar goldfish. The goldfish is not native to Britain, indeed it has for so long been domesticated both for food and as an ornamental fish, that its origins are now lost in the mists of time. Its natural range is probably central and eastern Asia but as a domestic fish it has been traded widely. Escapes, or deliberate introductions have ensured that this species is now widespread in ponds, lakes and slow-flowing rivers throughout Europe and Asia. Escapes of pet fish have also resulted in feral populations in North America. The first record of its presence in Britain is contained in *Ode On the Death of a Favourite Cat, Drowned in a Tub of Gold Fishes*, written by Thomas Gray in 1742 – the fish in question were being kept in a garden pond by Horace Walpole. Goldfish kept as pets are nearly all of the gold form, a colour variety which has been selectively bred in captivity. Feral populations usually revert fairly rapidly to a more drab greeny-brown colour.

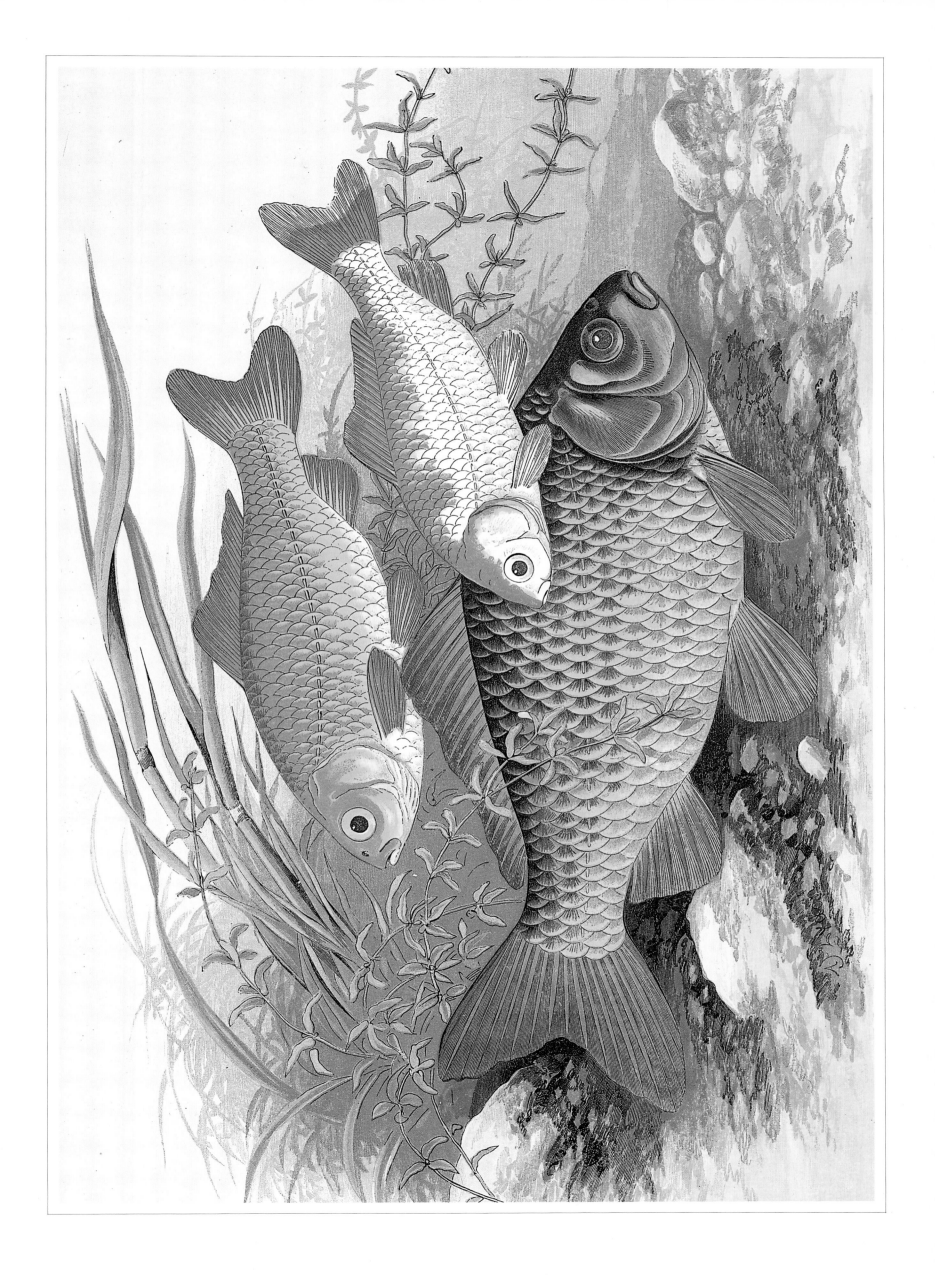

Pike

PIKE, *Esox lucius*. Colour printed wood engraving by Benjamin Fawcett after a drawing by A. F. Lydon, pl. 18 from W. Houghton's *British Fresh-water Fishes*, 1879. Size of plate 14″ × 10½″.

The pike is one of the most notorious freshwater fishes in Europe and North America. It is reputedly one of the most voracious, although some accounts of its predatory habits, including attacks on humans, are fanciful. The Reverend William Houghton relates one well-attested incident involving a youth, however, which took place in June 1856 when a fifteen-year-old son of Mr George Longhurst went swimming, with three other boys, in a pond near Ascot Racecourse. According to Mr Longhurst his son 'walked gently into the water to about the depth of four feet, when he spread out his hands to attempt to swim; instantly a large fish came up and took his hand into his mouth as far up as the wrist, but finding he could not swallow it, relinquished his hold, and the boy turning round, prepared for a hasty retreat out of the pond; his companions who saw it, also scrambled out of the pond as fast as possible. My son had scarcely turned himself round when the fish came up behind him and immediately seized his other hand, crosswise, inflicting some very deep wounds on the back of it; the boy raised his first-bitten and still bleeding arm, and struck the monster a hard blow on the head, when the fish disappeared.' The boy suffered great pain and lost the nail of his little finger, which had been bitten through, but recovered. A few days later the pike was discovered in a dying state by a woodsman; it measured 41 inches in length.

This picture shows some of the pike's fearsome teeth but there are others, sharp and backward-pointing, in the roof of the mouth. This array of teeth makes it difficult for prey to escape. Occasionally a pike is found with another pike, of roughly comparable size, jammed in its mouth, for it is not only rapacious but cannibalistic. Fortunately it does not subsist upon young lads and members of its own kind alone; normally it is content to dine off frogs, smaller fish, ducklings and other young water fowl.

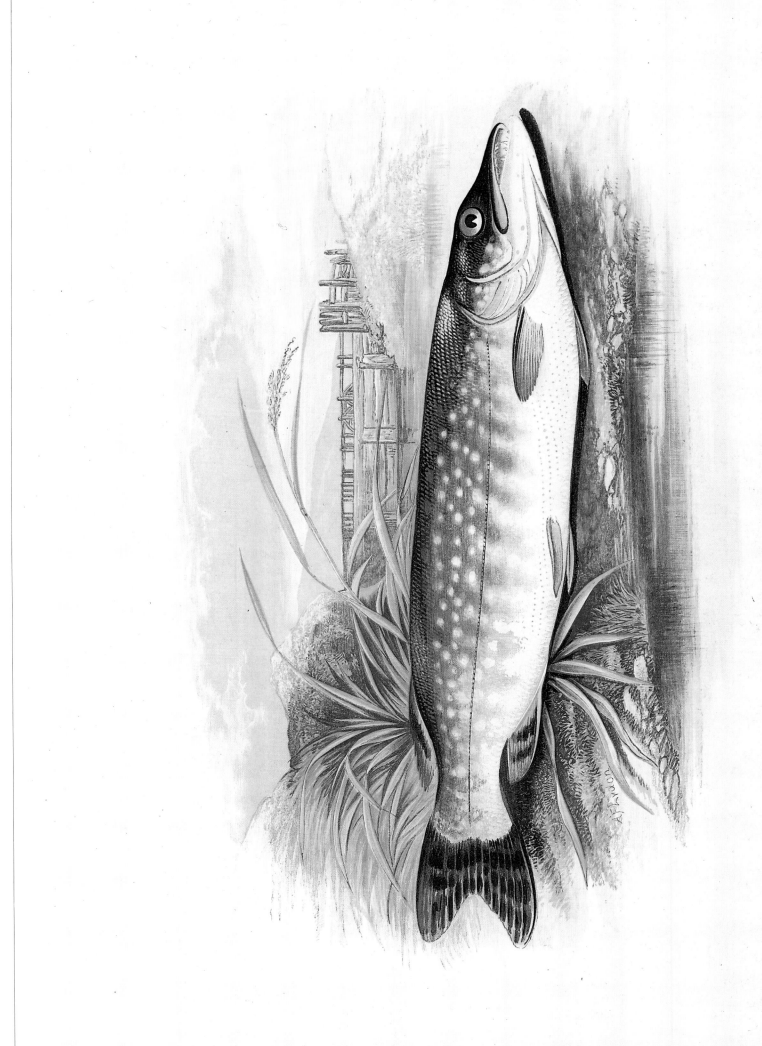

Sturgeon

STURGEON, *Acipenser sturio*. Colour-printed wood engraving by Benjamin Fawcett after an original drawing by A.F. Lydon, pl. 39 from W. Houghton's *British Fresh-water Fishes*, 1879. Size of plate 14″ × 10½″.

The sturgeon, like the salmon, spends most of its life at sea, but migrates into fresh water to spawn. Lacking the agility of the salmon it is less able to surmount obstacles and this restricts the number of rivers providing access to suitable breeding grounds. Increased industrialisation, man-made obstructions and pollution have further restricted its breeding range. It is almost extinct in western Europe.

The sturgeon does not breed in Britain now but it is caught occasionally in British waters, especially in estuaries. A statute of Edward II deemed it a Royal Fish. The occasional British records justify its inclusion in the Reverend William Houghton's *British Fresh-water Fishes*, a book justly famed for its attractive illustrations. His idiosyncratic comments about the edible properties of this fish are worth repeating. 'Sturgeon's roe is the *caviare* of commerce', he says, 'a thing, in my opinion, disgusting in appearance, offensive to the smell, and horrible to the taste. The sturgeons supply the greater part of this, so called relish. It is prepared near the mouths of the Volga, Danube, Dneiper, and Don . . . According to M. Littre, the name *caviare* is derived from the Turkish *chouiar*; what that means I do not know. The word to me, when I see the substance on the breakfast table, always suggests *caution* . . . I have never tasted a sturgeon, and should not know how to cook it. Yarrell says it is generally stewed with rich gravy, and the flavour is considered to be like that of veal.'

Speaking of the great size sometimes attained by this fish, Houghton quotes the *Leeds Mercury* of 1 February 1879: 'The largest sturgeon ever delivered to the port was brought into Grimsby on Wednesday morning by the smack *The Kitty* . . . The sturgeon was four feet eleven inches in circumference, eleven feet nine inches in length, and weighed forty-four stones and a half [282 pounds]. It was sold to Mr A. Clifton, fish merchant.' It is unlikely that Mr Clifton sold any part of this leviathan to the Reverend William Houghton.

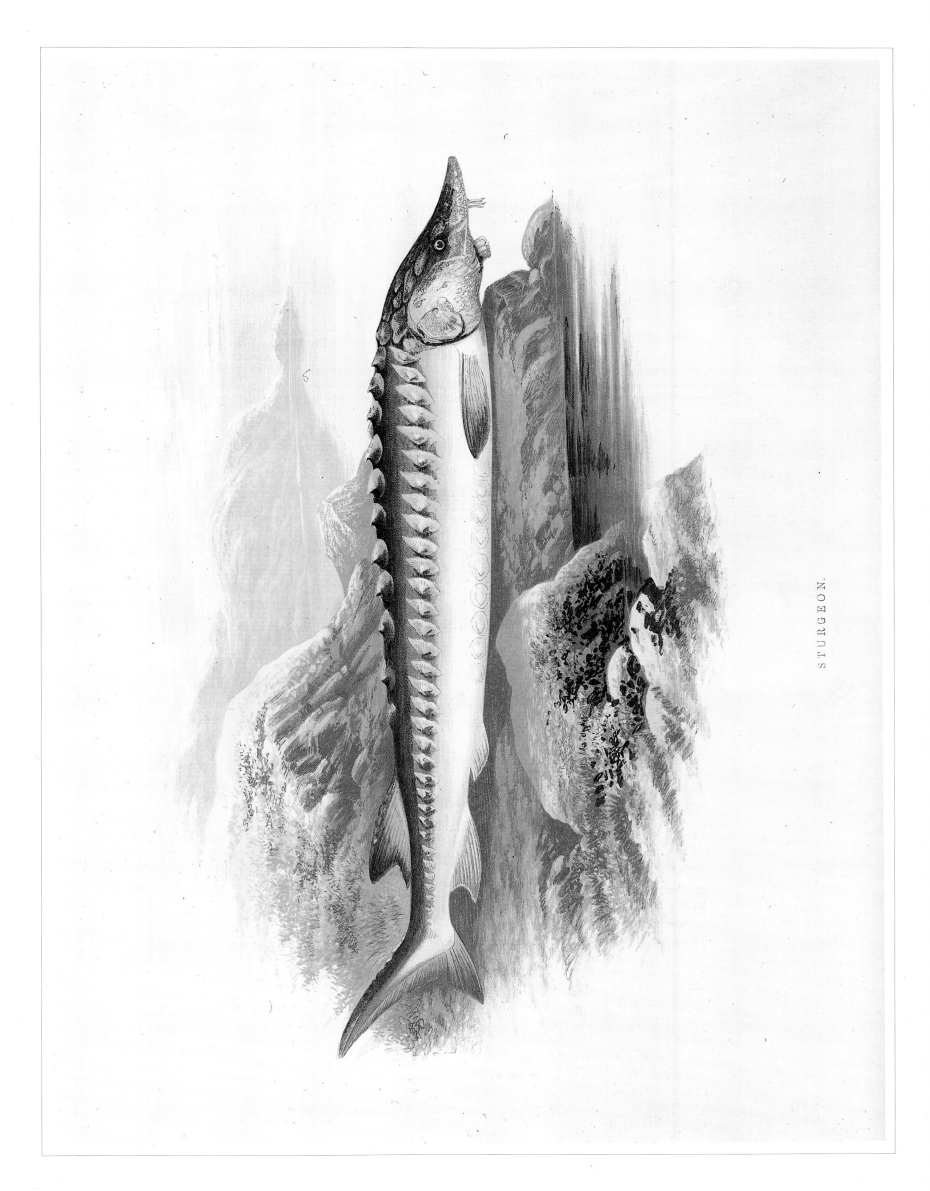

STURGEON.

Lampreys

SEA LAMPREY, *Petromyzon marinus* (top), Lampern, *Petromyzon fluviatilis* (now *Lampetra fluviatilis*) (second from top, and bottom), Planer's Lamprey, *Petromyzon branchialis* (now Brook Lamprey, *Lampetra planeri*) (third from top). Colour-printed wood engraving by Benjamin Fawcett after an original drawing by A. F. Lydon, pl. 41 from W. Houghton's *British Fresh-water Fishes*, 1879. Size of plate 14″ × 10½″.

The creatures shown here differ so fundamentally from other fish that some zoologists do not include them in this group. Superficially a lamprey resembles an eel but lacks jaws and paired fins. The adult lamprey has a circular, sucking mouth armed with horny teeth. The sea lamprey and the lampern use the mouth to clamp themselves to other fish and, vampire-like, suck their blood. Planer's lamprey does not feed when adult.

Lampreys have a complex life history. Larval lampreys, which lack eyes and the sucking mouth, bury themselves in the mud of rivers and feed on microscopic plants. After several years they undergo a dramatic change: they develop large eyes and the distinctive mouth of the adult.

Lampreys are nutritious and tasty. William Houghton's book, a mine of curious anecdotes, tells us that they were a gourmet food, Henry I having died of a surfeit of them and Henry IV having 'granted protection to such ships as brought over lampreys for the table of his royal court.' To this day the citizens of Gloucester send lampreys, baked in a pie, to the reigning monarch to mark special occasions, such as the Silver Jubilee of Elizabeth II in 1977.

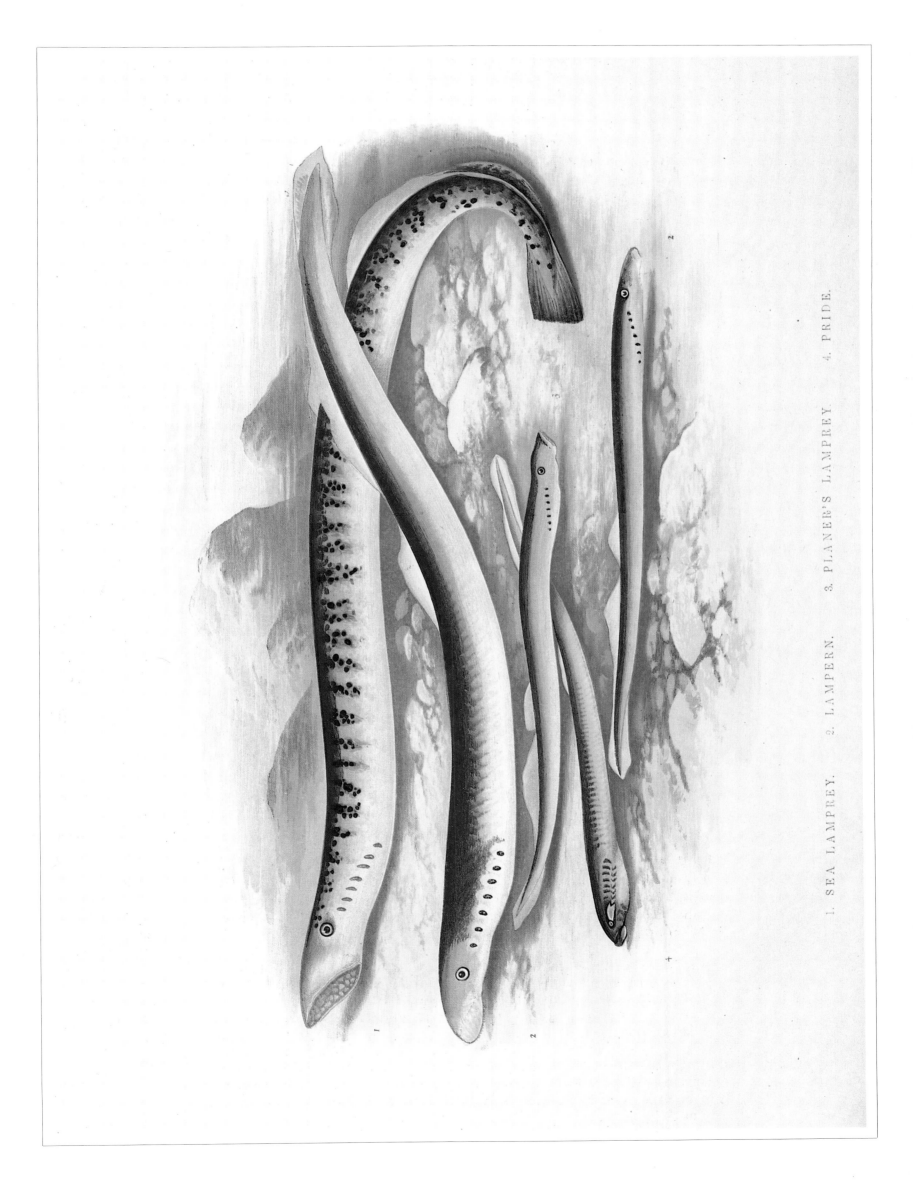

1. SEA LAMPREY. 2. LAMPERN. 3. PLANER'S LAMPREY. 4. PRIDE.

Lumpsucker

LUMPSUCKER, *Cyclopterus lumpus*. Chromolithograph from drawings by Gösta Sundman, pl. 32 from G. Sundman and O. M. Reuter's *The Fishes of Finland*, 1883–93. Size of plate 16″ × 10½″.

The popular name of this fish is derived from the modified fin on its breast which functions as a sucker enabling it to clamp itself on to rocks. It lives in the northern part of the Atlantic and stays near or on the sea bed down to a depth of about 150 feet.

The colours with which the artist has invested the three specimens shown in this illustration are misleading. Lumpsuckers are usually mid- to light grey in colour, as in the top figure, except in the breeding season when the males develop a red or orange belly and a more blueish back (bottom right). After spawning the males guard the developing eggs and so remain near the spawning sites close inshore long after the females have returned to deeper water. Following storms their conspicuously coloured bodies are sometimes washed up on shore. The figure at bottom left is probably meant for a male in breeding colours but it seems that the artist, or whoever was responsible for the colouring of the published plate, has been too generous with red pigment.

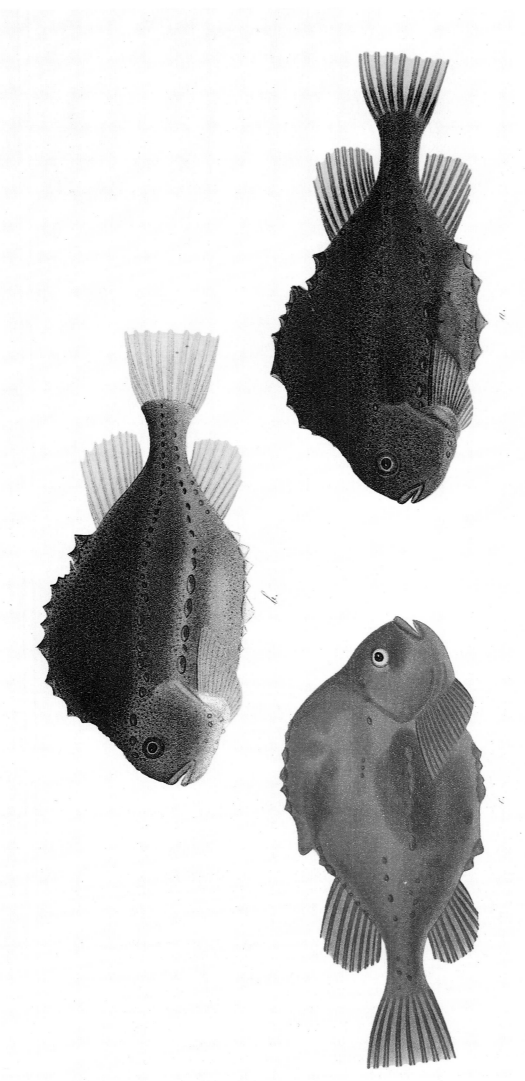

Cyclopterus lumpus L.

Sjuryģģ ⧠ Rasvakala, vilukala.

Cuckoo Wrasse and Corkwing Wrasse

Labrus mixtus (now Cuckoo Wrasse, *Labrus bimaculatus*) (upper two), *Labrus melops* (now Corkwing Wrasse, *Symphodus melops*) (bottom). Hand coloured lithograph by W. von Wright, pl. 2 from B. Fries, C. V. Ekstrom and C. Sundevall's *A History of Scandinavian Fishes*, second edition, revised and completed by F. A. Smit, 1892–95. Size of plate 13″ × 10″.

The wrasses, a large and colourful group, occur in all tropical seas and a few species occur in temperate waters. The two species shown here are both found in the Mediterranean and the eastern Atlantic, the cuckoo wrasse being recorded as far south as Senegal. The corkwing wrasse is much the smaller of the two, reaching a maximum length of six inches, and is less colourful, varying from a greenish hue to a reddish brown. The males are the more brightly coloured and have wavy red stripes on the head at spawning time. They also grow faster than the females.

The artist has attempted to show here the very different coloration of the female (middle figure) and the male cuckoo wrasse, but when the illustration was published, in the 1890s, it was not known that, like many wrasses, it changes sex. Some individuals are of the male sex throughout their lives. Others begin life as females but then become males. In many populations these secondary males are the only ones that normally court the females. Still other individuals remain as females.

The fish shown in the upper figure, with its brilliant blue head and flanks, is certainly a secondary male, but it may have spawned previously as a female before changing sex. The middle figure shows a fish that may be either a primary male, a female or a hermaphrodite in the process of changing from a female into a male. It is often very difficult to determine the sex of these 'red phase' fish. Individuals of the corkwing wrasse, by contrast do not normally change sex.

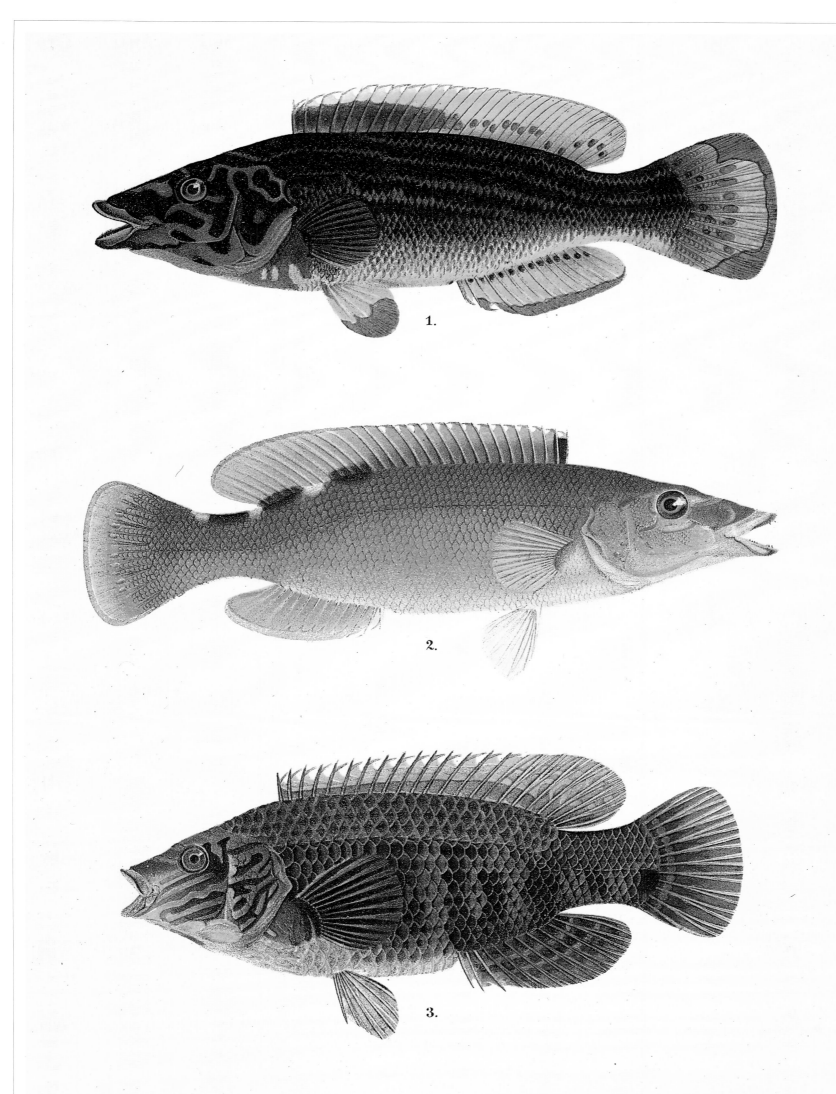

1 et 2: Labrus mixtus; 1=♂, 2=♀; 3: Labrus melops.

Tanganyika Catfish

Synodontis multipunctatus (now Tanganyika Catfish). Hand coloured litho-graph by J. Green, pl. 8 from G. A. Boulenger's *Report on the collection of fishes made by Mr J. E. S. Moore in Lake Tanganyika during his expedition 1895–96* (in *Transactions of the Zoological Society of London*, Vol. 15, Part 1), 1898. Size of plate 12″ × 9½″.

The fauna of Lake Tanganyika is remarkable for the large number of creatures of all kinds which are found nowhere else, many of them very different from related creatures from other African localities. It contains many species of fish, of which this is one. A member of the mochokidae, a family of catfish, it is one of more than 160 species characterised by having an often serrated spine in front of the pectoral fin just behind the gills. When the fish is handled out of water the movements of this spine make sounds similar to that of a door hinge needing some oil, which is why the South African name for this kind of catfish is 'squeaker'. The Tanganyika catfish grows to a length of eleven inches or more and, like other related species, is probably most active at dawn and dusk.

Georges Albert Boulenger, a Belgian, worked for many years at the Natural History Museum in London, where he became an internationally renowned expert not only on fish but also on reptiles. He was one of many eminent zoologists whose researches were published in the *Transactions*, the earlier issues of which were often illustrated with beautiful hand coloured lithographs.

Trans. Zool. Soc. Vol. IV. Pl. VIII.

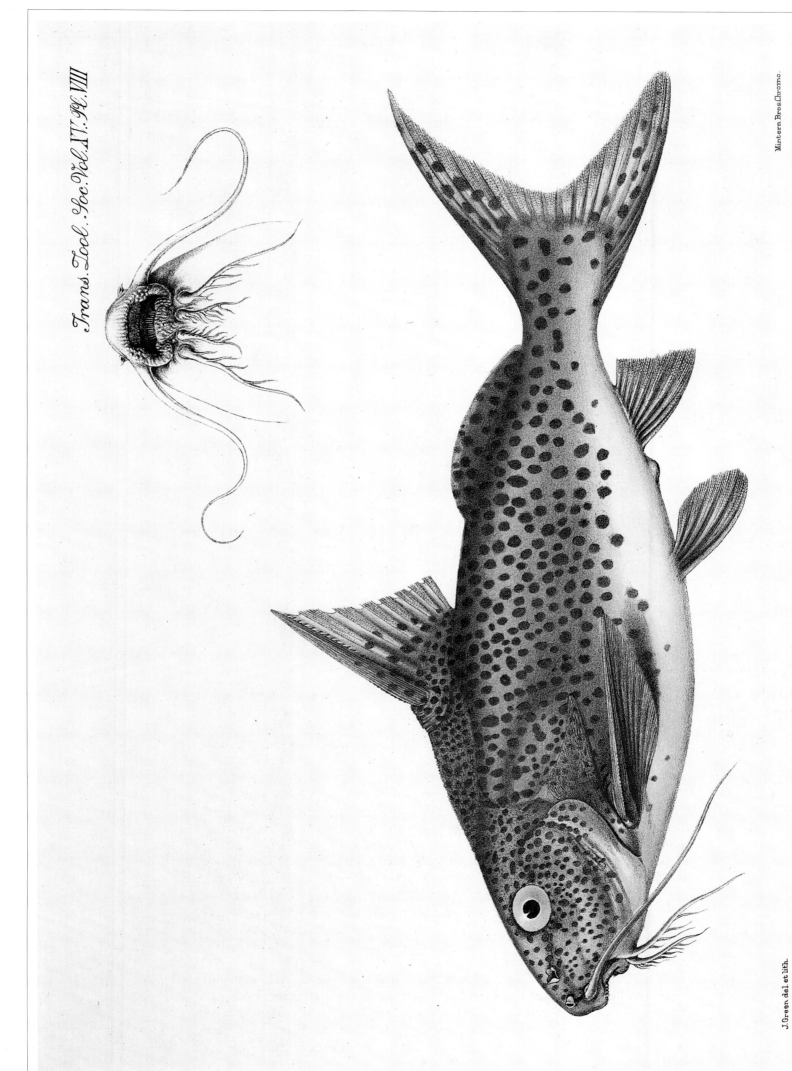

SYNODONTIS MULTIPUNCTATUS.

Trunkfishes

LONG-HORNED COWFISH, *Lactoria cornuta* (figures 1–5) and various other Trunkfishes (family Ostraciidae). Chromolithograph by Adolf Giltsch after drawings by Ernst Haeckel, pl. 42 from Haeckel's *Kunstformen der Natur*, 1904. Size of plate 11″ × 8″.

These remarkable creatures are known as trunkfishes or boxfishes from the shape of their bodies; seen from the front, their outline may be three-, four-, or five-sided. They rarely exceed twelve inches in length and are very restricted in their movements, the head and body being enclosed in an unyielding armour formed by the union of bony, hexagonal plates; the fins, tail and mouth are the only external parts that move. The alternative name cowfishes has been given to some species with forward-projecting spines on their heads. Forty or more species, of which some are reputed to have poisonous flesh, occur in tropical and sub-tropical waters.

Ernst Haeckel, the originator of these artistic and scientifically correct illustrations, was renowned as a devoted supporter of the evolutionary doctrines of Charles Darwin. He was also well known as a controversial thinker; and his attractive style of writing brought him a wide readership both in his native Germany and abroad. Beguiled by the apparently inexhaustible diversity of shape and pattern among animals and plants, he published a series of plates based on his own beautiful drawings. It is by these Haeckel is likely to be remembered, for his controversial thoughts and popular writings are now largely ignored.

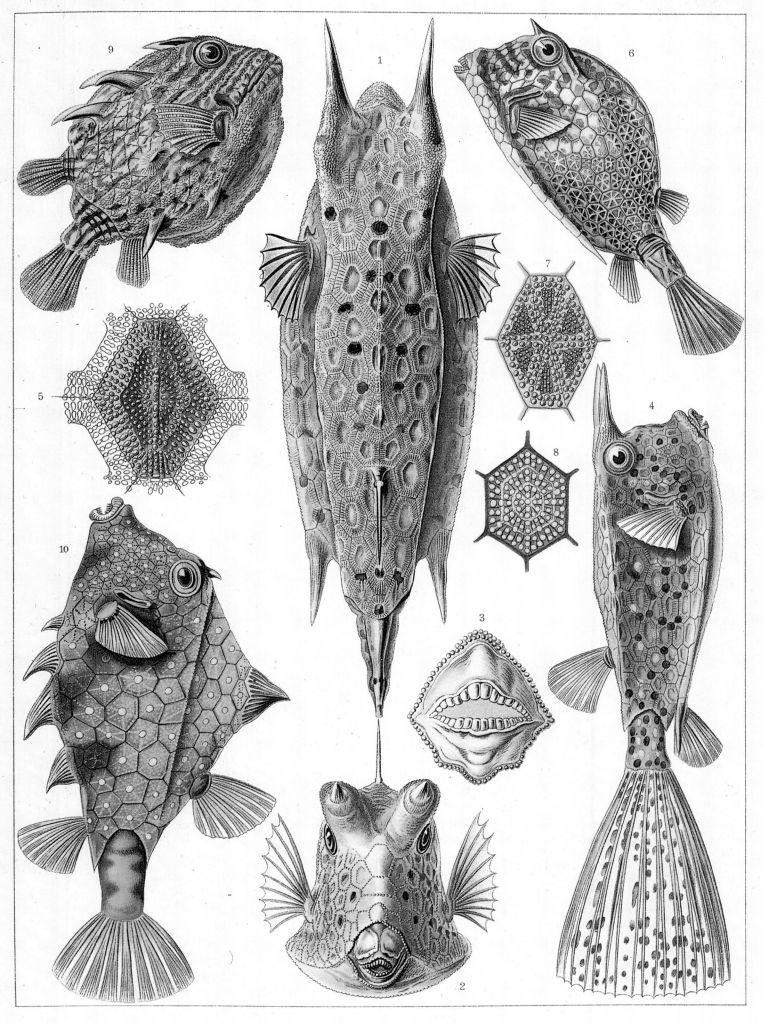

Ostraciontes. — Kofferfische.

Three Deep-sea Fish

Platyberyx opalescens (top), *Diretmus argenteus* (centre), Fangtooth, *Anoplogaster cornuta* (bottom). Coloured lithograph after drawings by Emma Kissling, pl. 5 (left half only) from E. Zugmayer's *Poissons des Campagnes du Yacht Princesse-Alice 1901–1910*, (fascicule 35 of *Résultats des Campagnes Scientifiques Accomplies sur son Yacht par Albert I Prince de Monaco*), 1911. Size of plate 13½″ × 10½″.

Albert I, Prince of Monaco, was in a privileged position to undertake marine research and he used his yacht, *Princesse Alice*, to study deep-sea life in the north-eastern Atlantic and the Mediterranean. Among his catches were these bizarre fish, which come from very deep water and differ strikingly from their brightly coloured cousins of the sunny shallows above. Because they are usually seen only by oceanographers and professional zoologists such fish seldom receive popular or common names; and our knowledge of their habits is skimpy because they are often dead by the time they are hauled up to the surface.

Platyberyx opalescens, a rarely caught fish measuring about 22 inches in length, lives at depths of 600–2,500 feet and most of the recorded examples have come from the Atlantic. We know more about *Diretmus argenteus*, which occurs around the world in tropical and temperate seas down to about 2,000 feet. It feeds on plankton and is thought to produce a noxious secretion which may deter predators. The laterally flattened body shape reduces the silhouette size of the fish when seen from below, assuming there is enough light for it to be seen at all. The large eyes may help to improve its own vision. It should be remembered that many deep-sea fish have light-producing organs of their own, which may be another reason why fish such as this have developed large and efficient eyes.

The fangtooth, so-called for obvious reasons, also has a worldwide distribution and, like the other two fish illustrated here, lives in the twilight zone of deep oceans. A mere six inches long, its skin is as rough as sandpaper.

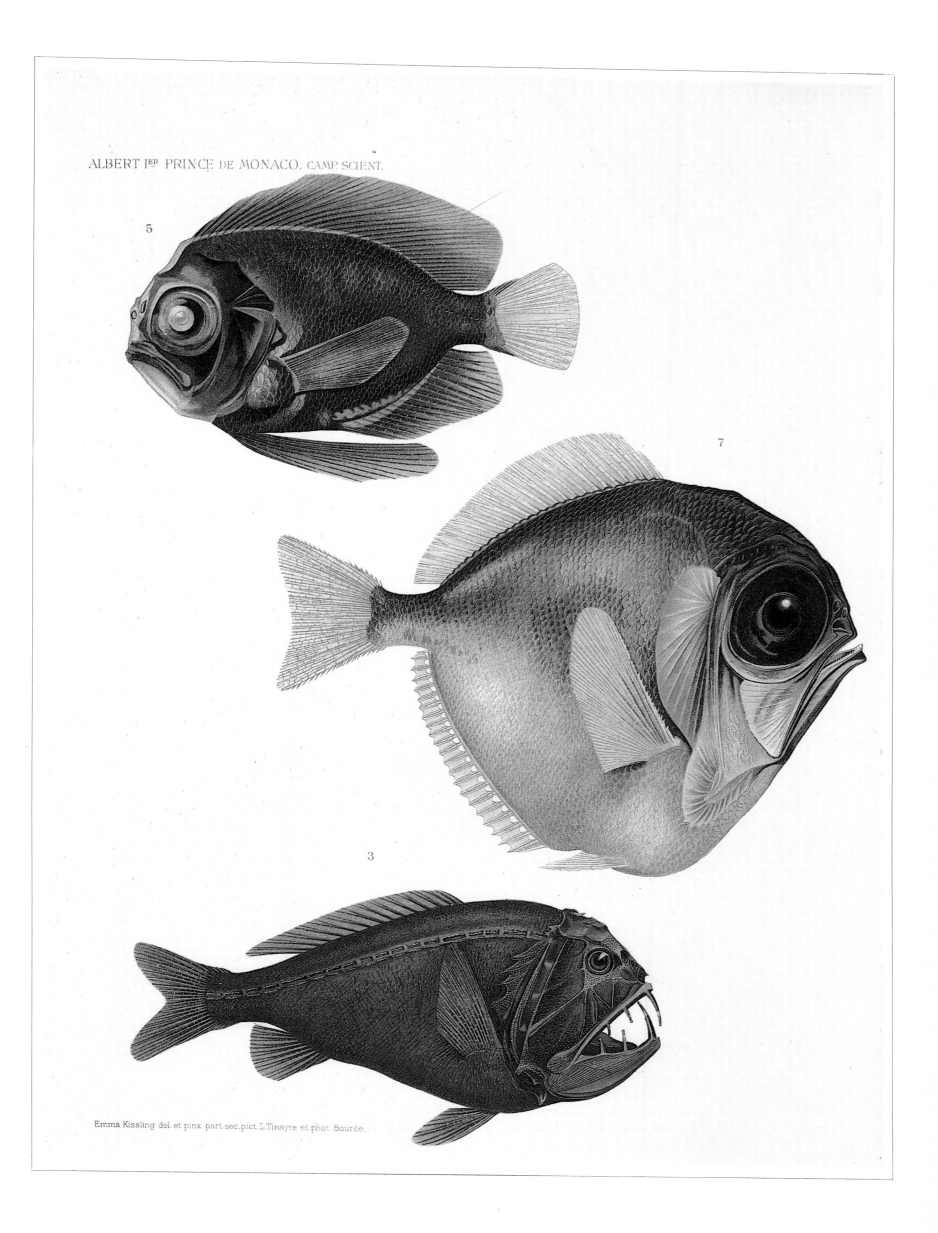

Emma Kissling del. et pinx. part. sec. pict. L.Tinayre et phot. Bourée.

INDEX